LOST COUNTRY HOUSES OF
THE NORTH EAST

IAN GREAVES

AMBERLEY

This edition first published 2024

Amberley Publishing
The Hill, Stroud
Gloucestershire GL5 4EP

www.amberley-books.com

British Library Cataloguing in Publication Data.
A catalogue record for this book is available from the British Library.

ISBN 978 1 3981 0687 1 (print)
ISBN 978 1 3981 0688 8 (ebook)

Typesetting by SJmagic DESIGN SERVICES, India.
Printed in Great Britain.

Contents

Introduction

This is not the first book to describe the lost country houses of Northumberland and County Durham. This new volume builds on the work of previous authors, and hopefully brings the subject up to date. Necessarily selective in the houses featured, it also includes a list of lost houses which is as comprehensive as I can make it.

The histories I have included are as accurate and complete as possible; however, I am well aware that there will be mistakes or omissions and for these I can only apologise. I would, of course, be delighted to receive corrections, illustrations or further information. Similarly, I would be happy to assist, where I can, with information regarding individual houses, on request. Please contact me at ian@doctors.org.uk

I am most grateful to my family for putting up with this project over several years and I would also like to take this opportunity to thank all the staff of the local libraries, history departments and archives for their kindness in locating material for me. In addition to the very many people listed in the illustration credits, thank you so much to Sandra Brack, JP Curry, Jane Dodd, Barrington Kirkham, Chris Lloyd, Michael Marsh, Ged Parker and Trevor Thorne. A full list of illustration sources is given at the end of the book, but I would like to pay particular tribute to Matthew Beckett and his Lost Heritage website.

County Durham and Northumberland have inevitably been shaped by their histories. Anciently, Northumberland was the violence-torn buffer state between Scotland and England, the lands of the Percys of Alnwick and a host of lesser but equally belligerent border tribes – County Durham the seat of the bishops of Durham who exercised unique temporal authority under the monarch as prince bishops. These powerful princes of the Church held temporal as well as spiritual power under the monarch from 1075, with the right to raise an army, issue currency and raise taxes. The last prince-bishopric ended as late as 1836, their temporal power long a thing of the past.

In recent times, a more useful division might be into the industrial south: the eastern part of County Durham and Northumberland as far as the north edge of Newcastle, and the Durham Dales and rural northern Northumberland. The south of the region is now largely a post-industrial area, typified by former mining villages and the industrial towns and cities of Newcastle, Sunderland, Gateshead and others. Only in the far west, in the lovely Durham Dales, is the ancient landscape of pre-industrial County Durham to be found. The loss of heavy engineering, railways, shipbuilding, and most importantly of all, coal, has left a difficult legacy of recent decline, high unemployment and architectural blight and recovery has been slow and is ongoing. The north of the region remains a land of small agricultural towns and a surprising number of still surviving estates.

Whereas houses in north Northumberland tend to have been lost as a result of the decline of the country estate due to death duties or falling rents or loss of income from industry, those in Newcastle and County Durham were lost more often than not as a result of industrialisation of their former estates, mining subsidence or urban expansion.

Newcastle was a major port and commercial centre from medieval times, but only in the late eighteenth and nineteenth centuries did it grow at an exceptionally rapid rate, its industry fuelled by the ever-expanding Durham coalfields. Its wealthy merchants gradually moved out into the rural north, and the late eighteenth and early nineteenth centuries were, as elsewhere, the high point of the country house and large estate in the North East. At the same time many houses were engulfed in industrial and housing developments and abandoned and demolished as their families moved to more suitable parts or gave up the struggle altogether. A major country house, Anderson's Place, once stood within a stone's throw of Newcastle's Grey's monument and what are now the western suburbs of Newcastle and Gateshead once accommodated the richly wooded estates of the gentry and aristocracy. County Durham was never a county with a large number of major country houses and was anciently characterised by many small estates which had often been in the same ownership for centuries. Here the Industrial Revolution resulted in momentous changes that eventually left little more than the western dales free of industrial development. The discovery of rich seams of coal under these estates was very often simultaneously the source of their owners' wealth and their own destruction.

In terms of architectural destruction of buildings of national significance, the losses in these two northern counties, although numerous, have not, with rare exceptions, been catastrophic. In purely architectural terms, the only significant loss in County Durham was Nash's superb Ravensworth Castle which fell victim to mining subsidence and the encroachment of the Newcastle-Gateshead conurbation; the other losses, although significant, were smaller or medium seats which, although architecturally charming, were more significant for their local associations, sometimes with families of great antiquity in the region.

In Northumberland, there have been, in all honesty, no losses of national significance, but it is difficult not to regret the demolition of Haggerston, Norman Shaw at his most imperial, or Twizell, the pasteboard-Gothick fantasy castle of the Blakes who still retain the estate they have held for centuries. The houses of the North East fall, without unnecessary generalisation, into a definable pattern. A significant number began as peles or bastles – fortified houses in an area subject to raiding and counter-raiding across the border with Scotland. A few became significant mansions in late medieval and Tudor times. Only with the early modern period did the northern counties abandon the need for defence. Two periods of significant construction followed, the first in the later eighteenth century, the second fuelled by the Industrial Revolution in the nineteenth and first few years of the twentieth century. Robert Trollope in the seventeenth century and William Newton, John Carr and particularly John Dobson in the eighteenth and nineteenth centuries are the predominant names amongst the architects of the North East. Sadly, buildings by Norman-Shaw, Dobson, Daniel

Garrett, Nash, Ignatius Bonomi, Trollope and John Carr all feature in the list of lost houses.

I have identified around 100 lost houses in County Durham, in Northumberland approximately 120. In each case, around half the lost houses were abandoned in the face of expanding urbanisation or industrialisation and once lay under the modern towns and cities of Newcastle, Gateshead, Durham, Sunderland, Billingham and Darlington. As noted above, as late as the mid-nineteenth century, areas of west and north Newcastle and Gateshead were considered suitable as havens for escape from the rapid development of the Tyne valley. Redheugh Hall, with its views of the Tyne valley, was a country retreat for merchants from Newcastle across the river. The most striking group were the west Newcastle mansions of what were then leafy Benwell and Benton, of which only a rump survives. As in so many areas of the country, and more so in Northumberland than County Durham, many of the larger houses were simply too big to survive as private homes, ill-suited to modern living and too expensive to maintain from the resources of estates drastically reduced by death duties. In a few cases such as Neasham Hall and Swinburne Castle, the estates have remained in the hands of their ancestral owners, now resident in newer and more practical houses; more often land tenures dating back centuries have ended. By the time they were sold off, the majority of houses and estates had been the seats of the minor gentry for 100 or 200 years, leavened by an influx of wealthy industrialists, chemists and engineers. Amongst the owners of houses mentioned in this book are the developers of the world's first steam-powered turbine warship, the inventor of the electric light bulb and the nineteenth century's greatest pioneer of hydraulics and armaments. Sadly, post-industrial decline, especially in mining, heavy industry, shipbuilding and engineering, has robbed most formerly wealthy families of the wherewithal to maintain their relatively recently acquired estates.

I have included, where I can find them, ghosts and legends of the properties mentioned. I have also taken the opportunity to make reference to the famous associations of many houses. Amongst those who feature are Elizabeth Barrett Browning, Bobby Shafto, Horatio Nelson and his second-in-command at Trafalgar Cuthbert Collingwood, a north-eastern hero who used to fill his pockets with acorns, planting them on his walks with his dog Bounce, in order to ensure a future supply of oak for the Royal Navy.

The houses and estates described in this book offer glimpses of the history of two of England's most interesting and individual counties and I hope this small volume will contribute to a greater understanding of the rich history of the North East.

Lost Houses of County Durham

Ashbrooke Hall (Corby Hall), Sunderland

Ashbrooke Hall was an Italianate villa built in 1864 for the glassmaker James Hartley MP by the architect Thomas Moore. The house's most prominent feature was a dramatic seven-sided bay, each side with a tall round-headed window. Hartley's fortune came in part from a new patented process for producing plate glass by rolling. His glass was used in the Crystal Palace. On the death of Hartley's widow, the house was acquired by Thomas Short of Short Brothers shipbuilders and timber merchants. His widow, Mary Ada, lived at Ashbrooke until her death in 1932 when the house was bought by the Jesuits who converted the hall into a chapel and used the house as a retreat, renaming it Corby Hall after Ralph Corby, a Jesuit martyr. The Jesuits stopped using the hall in 1973 and it was demolished in 1976. The land was built over but a lodge survives.

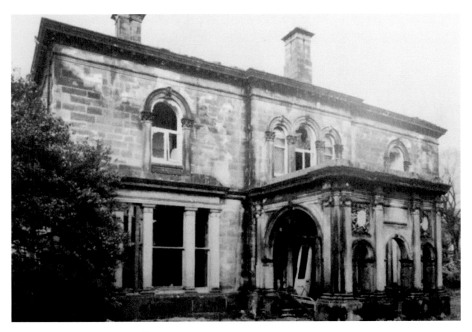

Ashbrooke Hall (Corby Hall).

Bainbridge Holme (Field House), Sunderland

Demolished in 1966, Bainbridge Holme dated from the Elizabethan period and was originally known as Field House. Outwardly, however, it gave the appearance of a typical eighteenth-century five-bay box with a prominent cornice and lower service

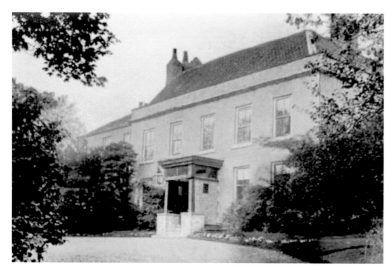

Bainbridge Holme
(Field House).

wing. One of the hall's fireplaces concealed a priests' hole. John Lumley granted part of his manor of Housefield to his servant William Mettew for life in 1405 and in 1539 a later Lumley granted the property to William Bainbrigg – hence its name. The Pemberton family later owned Bainbridge for around 300 years and still own land in the area, but lived elsewhere. Tenants included Charles Doxford, John Maling, Sir Cuthbert Sharpe, a collector of taxes, and in the late nineteenth century Nathan Horn, a glass manufacturer. For some years the house was empty as a result of the activities of the resident ghost Silky (a popular name for phantoms in the North East). John Joseph Binns, grandson of the founder of Newcastle's Binns department store, lived at Bainbridge from 1904 to 1935. Lawrence Pemberton restored the hall and occupied it until 1947. Its final owner was a Mr Talbot, who demolished it in 1964. Housing has been built on the site.

Billingham Hall, Billingham
In 1881, Billingham Hall, a Victorian house of the 1870s with a prominent square tower over the entrance, belonged to the shipowner James Graves, and in 1894 to CJ Watson. It was bought by Captain Jesse Lily in 1897 and by the Neilson family in 1909. The Neilsons owned it until 1922 and in the later 1920s it was the home of J. McGovern of Furness Shipbuilding. It was demolished in 1935 to make way for a housing estate.

Bishop's Manor, Darlington
A manor house of the Bishops of Durham stood on the site of what is now Darlington Civic Centre from 1164. Ruinous by the sixteenth century, it was restored by Bishop Cosin before falling into decay once more. The Manor was bought by the town for use as a poorhouse, a function it had already been filling for some time, in 1806. The council significantly extended and altered the building but many medieval features remained. Most of the Manor House was demolished in 1828, the remainder following in 1870.

According to local legend, during the Civil War a certain Lady Jarrett was staying, alone, in the Manor House when she was murdered by her footman. Another version recounts an assault by a band of marauding Roundheads whilst she was walking in the Manor grounds. Unable to remove a valuable ring, they are said to have cut off her hand leaving her alone, a bloody handprint on the floor nearby, before she collapsed and died. Either way, her ghost was soon seen about the property and the bloodstain proved impossible to remove. Her dress was long heard rustling about the Manor House and her spectre was reported on occasion to have turned up at the workhouse and made coffee for the residents. A tunnel is said connect the site of the Manor House to St Cuthbert's Church and Lady Jarrett is said to have settled below ground since the demolition of the Manor.

Bishopwearmouth Rectory, Sunderland

In 1650 a parliamentary memorandum reports of the rectory that

> whereas the parsonage house at Bishopwearmouth was in the year 1646 defaced and exceedingly ruined by armies, William Johnson admitted at the time to the rectory (by Parliament) has since disbursed considerable sums of money to make the place habitable – in all £48.8s.

Illustrations suggest a medieval date for the core of the building. Part of the house was rebuilt in the mid-seventeenth century by Revd Robert Gray. The work was finished by Dr Smith, who placed his coat of arms proudly over the door. The result was a grand and sophisticated seven-bay range with a single central dormer window and a central doorway with Dr Smith's inscription prominent above it. The Monkwearmouth living was traditionally a wealthy one with substantial lands and a significant income.

In 1855 the rectory was sold for demolition. Parts of the service wing survived for some years, but only the archway which once led to the stables now survives on a new site. A fine staircase, possibly dating from the sixteenth century, was moved to a new rectory which is now part of Sunderland University. In the 1830s, Valerian Wellesley, brother of the Duke of Wellington, was rector of Monkwearmouth.

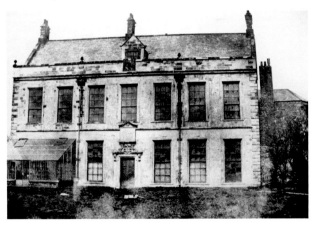

Bishopwearmouth Rectory.

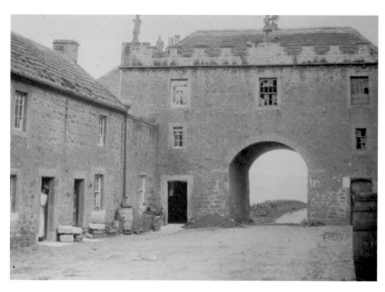

Black Hedley Hall.

Black Hedley Hall, Consett

Only a fragment of Black Hedley Hall survived into the twentieth century and is now lost. It was a residence of the Hopper family and later the Silvertops and was embellished with stone figures which are said to have inspired the career of the eminent Victorian sculptor John Graham Lough. The gatehouse at Black Hedley Hall was demolished in 1964, although the cottages on either side of the drive survive. The stone figures were removed to Shotley Hall.

Blackwell Hall, Darlington

The Blackwell estate belonged to the Allan family, originally from Staffordshire, from 1693. Their principle house, Blackwell Grange survives, much altered, as a hotel. Blackwell Hall was built in the late eighteenth century and extended in the early nineteenth by Robert Allan or his son John, who died in 1844. The hall had a narrow main block with long ranges running back from the main front, which had two prominent and turreted semi-circular bays.

The last Allan was Robert, who died in 1879 when both hall and grange were inherited by his cousin Sir Henry Havelock, who took the additional surname Allan (1830–97). He was succeeded by his son who sold Blackwell Hall to W. Stanley Robinson, a Darlington auctioneer.

Robinson lived in the hall for ten years, building a number of houses in the grounds. In 1940 the house was sold to Alexander Dickson and became Darlington's most exclusive hotel, which it remained until the 1960s. It was sold in 1963 to Raine Brothers, building contractors. More houses were built in the grounds and the intention was to convert the house into flats. However its poor condition led to its demolition and the site is now covered by housing.

The film producer Sir Anthony Havelock-Allan was born in Blackwell and worked on films including *In Which We Serve, Brief Encounter, Great Expectations*

and *Ryan's Daughter*. Major General Sir Henry Havelock KCB who relieved the siege of Lucknow in the Indian Mutiny was also a member of the family.

Blackwell Hill, Darlington

Blackwell Hill was a Gothic villa of the 1870s built on the site of the ancient Blackwell manor house. It was designed by John Ross and built for Eliza Barclay. Eliza was a wealthy widow and a member of the prominent Darlington banking family of Backhouse. For a time the house was used as a domestic service school for poor girls. Other owners included Edward and Rachel Backhouse Maunsey and John Neasham, garage owner and Darlington Football Club chairman who bought it in 1944. In 1969 Mr Neasham's son sold the house to a property developer who demolished it in the early 1970s and used the land for housing. The surviving lodge has been extended and restored.

Blackwell Manor House, Darlington

Blackwell Manor was an ancient seat, probably built by the Neville family. It was derelict by the mid-nineteenth century. Blackwell Hill was built approximately on its site.

Branksome Hall, Darlington

Branksome Hall was an early nineteenth-century house which was built for Robert Teesdale and originally called Westfield. In 1852 it was bought by the railway magnet John Kitching and increased in size by the addition of a new wing with a two-storey bay and dormer windows. The house was renamed from a poem by Sir Walter Scott. After Kitching's death in 1935 his seven bachelor sons lived on at Branksome until 1955 when they sold the estate to Darlington Council. The estate was used for disabled and elderly housing and the house demolished.

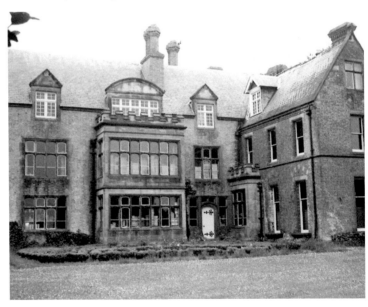

Branksome Hall.

Brinkburn, Darlington

Brinkburn was built by Henry Pease, the pioneer railway financier, for his eldest son, Henry Fell Pease. It was designed by John Ross and completed in 1862. Built of cream-coloured brick with sandstone dressings, it contained a drawing room with marble pillars. The house has been demolished but the stables survive as offices.

Broadwood Hall, Lanchester

Broadwood was built in 1875 for Edward Taylor-Smith of Colepike Hall, on the site of an earlier hall. A large three-storey house with a balustrade hiding the roof, Broadwood had canted bays on the ground floor. The entrance front had five bays, the central one recessed, the garden front three bays, the central one recessed. After the death of Taylor-Smith in 1888, the house was bought by the Penman family, who owned it until 1958. In 1960 the house was bought by the local building firm Cowies, who demolished it. A new house was built on the site. All that remains of the hall are four tunnel-vaulted basement chambers and fragments of wall.

Cleadon Old Hall, Cleadon

Cleadon Old Hall was built in the eighteenth century by John Burdon. In the late nineteenth century it was occupied by the shipowner Joseph Wilson. Thomas Bell bought the Old Hall in 1888 but around the turn of the century it was divided into several residences. James Humble, a retired farmer, and his wife lived in the hall from 1909 to 1927 and having fallen into decay, it was demolished in 1936. New housing was built on the site.

Cocken Hall, Cocken

From the mid-twelfth century Cocken belonged to the Priory of Durham. In agreement with Roger of Kibblesworth, the Priory exchanged it for lands at Wolviston and Roger's daughter and heir sold it to Finchale Priory. At the Dissolution, the lands of Finchdale Abbey passed to John and Isabel Hilton of Newcastle. Isabel's first husband was Ralph Carr and the Carrs owned Cocken until the nineteenth century. A seventeenth-century engraving shows a house in a distinguished formal setting which included terraced walks and views of the ruins of Finchdale Abbey. Cocken was occupied by Teresian sisters from 1804 to 1830 when a coal mine was opened nearby. By this time, the pleasure grounds had deteriorated. William Standish Carr (1807–56) succeeded his relative Frank Hall Standish of Duxbury Park, Lancashire, in 1840, changing his name to Standish. Standish reduced the house in size, transforming it into a rather random Victorian mansion. Tradition has it that Standish committed suicide by riding his horse off a nearby cliff and his ghost is said to haunt the area.

Cocken was later the home of John Gully (1783–1863), innkeeper's son, butcher, prize-fighter, racehorse owner, coal owner and MP. On his death in 1863, Gully left twenty-four children from two marriages. The shipowner Ralph Milbanke Hudson lived at Cocken, which then became part of the estate of the Earl of Durham. During its ownership by the Durham estate the house

was left empty and was looked after by a caretaker by the name of Herdman, who, in 1914, found the house vandalised with slogans including 'votes for women'; inside preparations for a major fire were in place. On this occasion the destruction of the house was averted. Unfortunately, after use by the Durham Light Infantry during the First World War no further use could be found for it and it was demolished.

Cockerton Hall, Darlington

Cockerton Hall was originally a medieval house, probably belonging to the Neville Earls of Westmorland. Some medieval features survived until its demolition. In 1745, Cockerton became the property of William Wrightson, one of the Wrightsons of Neasham. His daughter Nanny, who died in 1829, remodelled the front of the house in 1825 and left Cockerton to her nephew Richard Wrightson, who died in 1830, leaving Cockerton to his wife, Eliza. Wrightson's will, written on a half sheet of notepaper, was contested in the 'Cockerton Will Case', but the House of Lords eventually found in Eliza's favour. Eliza later married again, to Thomas Topham who died in 1873 and left Cockerton to his brother the Revd John Topham. The hall was let and was for a period a ladies' school (1841–61). Cockerton Hall was later occupied by Alfred Jobson, colliery agent for the Peases, and by the Stocks, Jeffreys and Craddock families. From 1920 to 1946 it was the home of Charles Freeman Thomas. In 1946 it was bought by a cinema chain and leased to Darlington Youth Club. After a period as a Post Office store it was demolished in 1964.

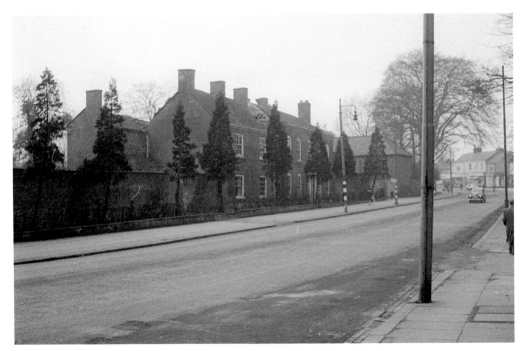

Cockerton Hall, Darlington.

Consett Hall, Consett

In 1856 Consett Hall was the home of George Foster and in 1884 William Jenkins, both managers of the Consett Iron Works. The house appears to have been rebuilt in the middle of the nineteenth century in brick with Gothic detailing.

Coxhoe Hall, Coxhoe

The first house on the site was built around 1300 and Coxhoe was the seat of the Blackistons of Norton from around 1400 to 1600. This house was ruinous by 1418 but was rebuilt in Tudor times. Soon after 1600, Mary Blackiston married Sir William Kennett of Sellenge, Kent. Royalist during the Civil War, Samuel Kennett was killed at Marston Moor. Thereafter, Coxhoe remained a seat of the Kennetts until 1714 when Mary Kennett married William, 5th Earl of Seaforth. Seaforth, a supporter of the Jacobites, left the country after the '15 Rebellion and the estate was sold in 1725 to John Burdon.

Burdon rebuilt Coxhoe as a plain classical box which was subsequently 'Gothicised' with the addition of turrets and battlements. Burdon bought Hardwick Hall in 1748, commissioning a new house and extensive landscaped gardens. The expense of his new house bankrupted Burdon and in 1758 he sold Coxhoe to John Swinburn, husband of his niece Sarah Burdon. On Swinburn's death he was succeeded by his brother William Swinburn who was in his turn succeeded by Major William Swinburn. Following a disputed inheritance, a Chancery order led to the sale of Coxhoe in 1794. After this, Coxhoe passed through a number of hands, most notably those of Edward Moulton Barrett and his wife who rented the estate during the early years of the nineteenth century. Their daughter Elizabeth Barrett, later Elizabeth Barrett Browning, was born at Coxhoe in 1806. In 1817 Anthony Wilkinson bought the estate and in 1850 it passed to the mining engineer Thomas Wood who made a number of additions including a single-storey billiard room. Wood was succeeded at Coxhoe by his son William Henry Wood who died in 1910. After his death, his widow lived on at Coxhoe until 1928 when their son succeeded her.

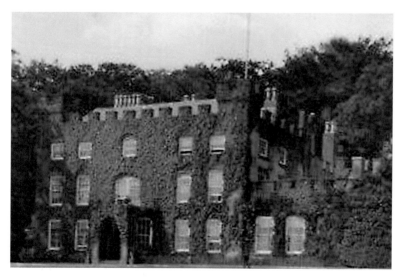

Coxhoe Hall.

Coxhoe was put up for sale in 1938 and bought by the East Hetton Colliery Company. During the Second World War it was used to house prisoners of war. When the war ended, the house was left empty and occupied by squatters. Following vandalism and mining subsidence it was condemned by the Coal Board and demolished in 1956.

Coxhoe had good rococo plasterwork, possibly designed by Paine and carried out by Giuseppe Cortese (who also worked at Elemore and Hardwick). The hall was said to be haunted by the blue lady, a maidservant from one of the houses in the village who fell in love with the coachman at the hall. Becoming jealous on seeing the maid talking to other men, the coachman locked her into a small cupboard in a remote corner of Coxhoe Hall and left her there to suffocate. Her phantom was said to haunt the hall and the nearby woods.

Cramlington House, Cramlington
A mid-eighteenth-century five-bay Palladian villa by John Dobson for AM de C. Lawson of Chirton, Cramlington House was built around 1815 and demolished in around 1969.

Crook Hall, Consett
The Crook Hall estate is mentioned in twelfth-century records. Originally the seat of the de la Ley family who were the Lords of Witton, by the late fourteenth century it was owned by Sir John de Kirkby. A later owner was Roger Thornton, known as the Dick Whittington of Newcastle, who started life as a country boy, arriving in the city with nothing and rising to fabulous wealth, becoming lord mayor three times. An old saying went 'At the Westgate came Thornton in with a hap, a halfpenny, and a lambskin.' Hap has various meanings including good luck and cloak, either of which would seem appropriate. Crook passed by descent to the Lumleys and then through various families to the Shaftos in 1588. The Shaftos

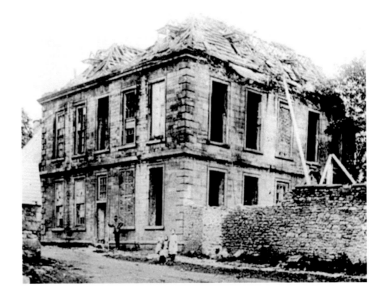

Crook Hall, entrance front.

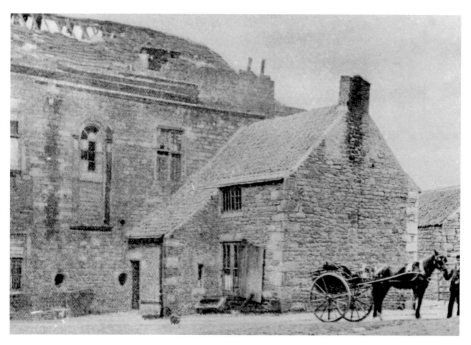

Crook Hall, rear view.

sold Crook Hall to the Bakers around 1640. George Baker remodelled or rebuilt the house in 1716. The Bakers had left for Elemore Hall by the 1790s and Crook Hall was rented for use as a seminary for professors and students from Douai during the Napoleonic Wars after a hurried evacuation from France in 1793. The seminary eventually moved to Ushaw and for the reminder of the nineteenth century the hall was used as a farmhouse or was disused.

Towards the end of the century, Consett developed as an iron and steel town and the Crook Hall Ironworks opened. Crook Hall was dismantled around 1900 and the stone used by George Neasham for a building West Park, Lanchester.

Dalton (Dawden) Hall, Dalton le Dale

A seventeenth-century house with medieval features, Dalton Hall was built with stone from the ruins of Dalden Tower and demolished in 1967. The hall passed by marriage from the Dalden family to the Bowes in 1375 and then to the Collingwoods, who abandoned it around 1600. Ralph Milbank owned the hall in 1777 but lived at Seaham Hall and sold Dalton to the Londonderrys in 1821. By this time, the hall was being used as a farmhouse. Lord Londonderry's agent, Robert Brydon, lived in the hall in the later nineteenth century and established a renowned Clydesdale horse stud there. The stud closed in 1915 when the prize Clydesdale was sold for £5,000 guineas (£310,000 at current values) and Douglas Murray became tenant. The hall was a long low building of two storeys and appears to have been constructed in a number of stages. Its most prominent feature was unusual stepped gables.

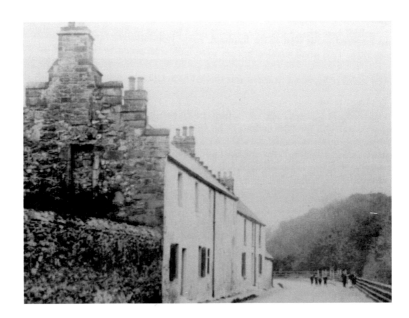

Dalton
(Dawden)
Hall.

Deanery (The), Chester le Street

Before the Reformation, Chester-le-Street was a religious foundation. In 1606 the Deanery estate was granted by James I to Sir James Ouchterlony and Richard Gurnard who held it as trustees for the Hedworth family. On the death of John Hedworth in 1747, the estate was inherited by his two daughters. One married John Hylton of Hylton Castle the other Sir Ralph Milbanke of Seaham and Halnaby. In 1857, the estate belonged to their descendants Charles Joliffe and

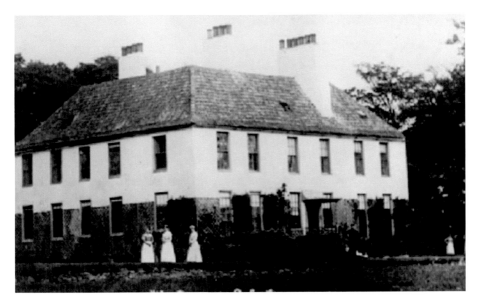

The Deanery.

Lady Byron (née Milbanke). In the early part of the nineteenth century the tenant was John Morton and he altered the house and developed the grounds. In 1834 the tenant was Edward Johnson and in the late nineteenth century the confectioner J. W. Luccock. The Deanery was demolished sometime between 1906 and 1911 when Park View Secondary School, which stands on its site, was opened.

Eshwood Hall, Brancepeth
Eshwood was built in 1874 for the coal owner Henry Cochrane and sold by Messrs Cochrane & Co. Ltd in 1926. The house was demolished in 1930 and replaced by a smaller modern house. At their peak, the gardens included extensive greenhouses, rockeries, ponds and waterfalls. In 1911 the US aviator Colonel Sam Cody stayed with the Cochrane family at Eshwood Hall, having made an emergency landing nearby.

Farnacres, Gateshead
Originally part of the Saltwellside estate, Farnacres passed to the Liddells of Ravensworth in 1671. In the eighteenth century it was the home of their bailiff Nicholas Watson. It was tenanted in the nineteenth and early twentieth centuries, the tenants including Revd R. H. Williamson, the brewer John Barras, and F. W. Bernard, the 'Low Fell Giant'. The estate gradually disappeared under the Team Valley trading estate and the house was demolished in the 1960s.

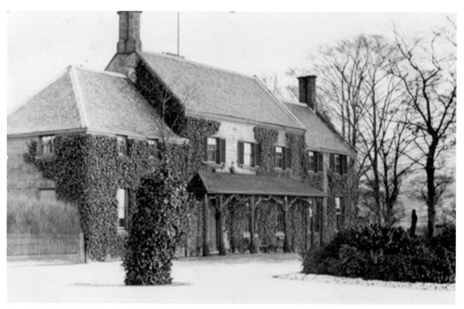

Farnacres, rear view.

Field House (Enfield House), Gateshead
In 1639 the Field House estate belonged to the Wilson family, stewards to the Lumleys. Field House was confiscated from the Wilsons during the Civil War and let to Ralph Clavering and Thomas Weld in 1644.

After the Restoration the estate belonged to Sir Ralph Carr, whose descendants sold it in a number of portions. In the 1830s, what remained of the original Field House estate was occupied by Joseph Shield, a Newcastle coal-fitter and shipowner who, presumably, commissioned the final house on the site, and in the 1880s by Arthur Newall. John Sowerby, a glass manufacturer, lived at Field House with his wife, six children and four servants in 1891. The house was one of Dobson's earliest commissions dating from 1813:

> most delightfully situate on a sloping lawn, commanding an extensive view of Ravensworth and the Tyne. The garden, which is exceedingly productive, is laid out with much taste and contains a vinery.

In the 1890s Field House was a boys' private school. What remained of the land was sold for development in parcels from around the same time and the house was demolished in 1931.

Ford Hall, Sunderland

Ford Hall was built by George Mowbray in 1785, on land acquired by his father from the Hyltons of Hylton Castle. In 1781 the Mowbrays sold it to John Goodchild of Pallion who let it to the Havelock family of Blackwell Hall and Blackwell Grange. General Sir Henry Havelock, hero of the Indian Mutiny, was born at Ford in 1795. Goodchild's bank failed in 1816 and Ford was sold to the local brewer Robert Fenwick who frequently let it. Tenants included James Laing and the shipbuilder and bottlemaker John Scott.

The Fenwick family sold the hall and 174 acres to Sunderland Corporation in 1924. By this time the hall had been vacant for twenty years and the Corporation demolished it, building houses on the site.

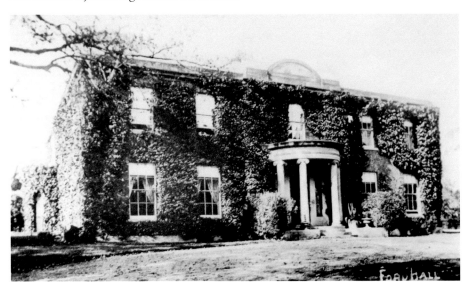

Ford Hall.

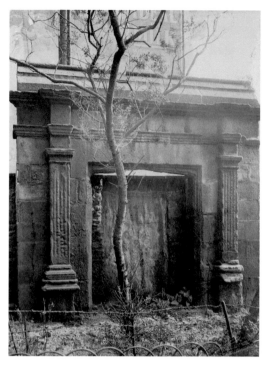

Gateshead House gateway.

Gateshead House, Gateshead

The only element of the long-demolished Gateshead House is its gateway which was moved to a different site. The house itself was built in 1595 by William Riddell, mayor of Newcastle. The Riddells remained at Gateshead House for several generations and Sir Peter Riddell was knighted by James I during a royal visit. In 1644 the house was damaged by Scots troopers whilst the residence of T. Riddell; it later passed into the ownership of the Claverings. Gateshead House was reduced to ruins by a rioting mob in 1746. The crowd had turned out to observe Bonnie Prince Charlie's army passing south and on occupying the house to get a better view were angered by the gardener's attempts to get them to leave. As a consequence the house was set on fire, destroyed with its contents, abandoned and later demolished.

Gateshead Park House

The Bishop of Durham held the park estate but leased it to the lord of the manor. In 1716 this was William Coatsworth, who rebuilt the house in 1723 (a fragment of this house with a Dutch gable may have survived to the side of the new building). Coatsworth also let out parts of the estate for industrial use and coal mining. Although a fragment of its former size, in 1836 the estate still extended to over 400 acres. Within a decade of the rebuilding, the house was enlarged by James Gibbs for Henry Ellison, son-in-law of William Coatsworth. A two-and-a-half-storey building of brick with stone dressings, the house overlooked the Tyne.

 The Ellisons built Hebburn Hall in 1790 and it became their main seat; as a result Gateshead Park was let, often to a local industrialist. The Church Commissioners acquired the estate in 1857 and sold much of it for building. The house was

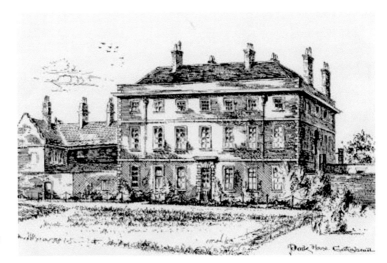

Gateshead Park House.

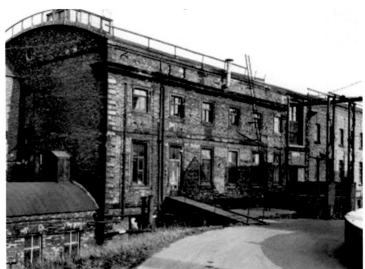

Gateshead Park House in industrial use.

acquired by the firm of Clarke Chapman in 1884. It was converted into offices before being burnt down in 1891. Parts of the house survived within industrial buildings in which Sir Charles Parsons developed the prototype steam turbine, until 1995 when they were demolished. Charlotte Bronte refers to a Gateshead Park House in Jane Eyre and local tradition holds that she stayed at the house.

Greatham Hall, Hartlepool

Greatham Hall was built by Dormer Parkhurst in 1725. In 1820 stucco was applied to the garden front and the hall was extended in 1857. At one time Greatham was the home of Ralph Ward Jackson, founder of West Hartlepool before his reputation was destroyed by accusations of dishonest financial dealings. Greatham Hall was demolished in 1962. A modern house on the site incorporates a small part of the original.

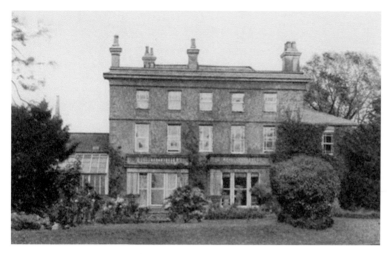

Greatham Hall.

Greenbank, Darlington

In the 1820s Greenbank was the home of Warren Maude. It became a maternity and children's hospital in 1885 and has now been demolished.

Greenbank.

Greencroft Hall, Lanchester

Greencroft was built around 1670, probably on the site of the medieval manor house of a deserted village. Sash windows and a classical porch were added in the eighteenth century and lower wings of two storeys and one bay were added in the nineteenth. The Claverings of Axwell Park, Blaydon, bought Greencroft from

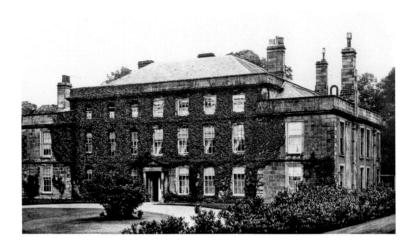

Greencroft Hall.

Ralph Hall in 1670. The house passed to Sir Thomas Clavering (1791–1853) and from him to his brother Sir William who died in 1872. Sir Thomas was a captive of the French for four years during the Napoleonic Wars. On Sir William's death Greencroft passed to an illegitimate brother, John Clavering (Axwell went to a nephew). The estate then passed to John's daughters, Agatha and Clara, who both married Belgian barons (the barons de Montfaucon and de Knyff, respectively). By 1930, Greencroft belonged to the du Quesnoys, descendants of the de Knyffs.

 After the death of John Clavering, the house was tenanted. At the start of the Second World War it was empty and it was subsequently occupied by the army. By the end of the war it was decaying. The fittings were removed and sold in 1954 and the house was demolished in 1960. The Greencroft estate had a Gothic arch with cottages, which was known as Greencroft Tower and fell victim to subsidence. The stables from Greencroft were dismantled and moved to the Beamish Open Air Museum where they form the visitors' centre.

Hallgarth Hall, Winlaton

Joseph Laycock built Hallgarth Hall in 1835. He became mayor of Newcastle in 1858. From the 1880s until 1925 the hall belonged to the paper-maker and colliery owner Herbert Wylam Grace. After being owned by Mr Ireland, a local market gardener, it became a social club after the club's previous premises burned down in 1947. Whilst in club ownership various insensitive additions were made. The club later ran into financial difficulties and closed. The hall was sold and demolished in 2016, housing being built on the site. Most of the garden is now a public park. Running alongside the former grounds is Love Lane, which was said to be haunted by the ghost of a maidservant from the hall. Tradition has it that she used to meet her lover, a miner from nearby Blaydon Burn Colliery, in the lane every night at six o'clock. Becoming pregnant, her faithless lover deserted her and both mother and child died during her labour. Her phantom was said to haunt the lane where she was deserted, sobbing uncontrollably and terrifying passers-by. The noises stopped in 1900, when, it is said, her faithless lover was killed in a mining accident.

Hallgarth Hall.

Hawthorn Tower, Easington

From a distance Hawthorn Tower had a convincingly ancient look. It was, in fact, entirely a nineteenth-century creation designed by John Dobson for Major George Anderson and built in 1821. It was enlarged around the middle of the century to the designs of Thomas Moore. Hawthorne Dene, on which Hawthorn Tower was built, was originally a property of the Milbankes of Seaham.

After Major Anderson, Hawthorn Tower belonged to the Pembertons of Low Barnes and Richard Pemberton was the owner in 1897. The Pembertons left in 1910 and the property was tenanted. In the 1930s the Boys' Brigade used the tower for weekend camps, and during the Second World War it was occupied by the military. The Pembertons returned briefly, before selling up in the late 1940s. The house was subsequently abandoned and became ruinous. It was demolished in 1969 after a partial collapse killed a child. No trace now remains.

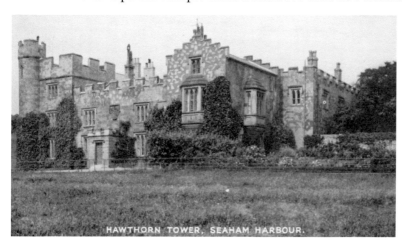

HAWTHORN TOWER, SEAHAM HARBOUR.

Hawthorn Tower.

Helmington Hall, Hunwick

The surviving Helmington Hall, albeit in poor condition, is the remaining fragment of a much larger house which was largely demolished after a fire in 1895. The lost nine-bay front range had scrolled pediments over the windows and door and dated from the end of the seventeenth century, the rear part from the late eighteenth. Helmington was sold by William Blackett to Ralph Spencer (1736–1805). It was enlarged for his son Revd Robert Spencer when two fine Gothic rooms were added, both now lost. The gardens were laid out at the same time. Spencer's widow lived at Helmington as late as 1856. Hunwick is one of the suggested locations of the Battle of Brunanburh, Aethelstan's victory which laid the foundations of the English state.

Hermitage (The), Gateshead

A large and unlovely mansion of 1870, The Hermitage was built for John Cotes Copland. William Clarke owned it in 1874 and in 1915 the marine engineer Robert Bales Armstrong was the occupier. Mrs Isaac Tucker of the nearby Turkshead Brewery lived at The Hermitage in 1901. By 1920, the house was a working men's institute; it was demolished in the mid-1960s after the club moved to a new site. There was a splendid classical arch over the entrance to the property, now sadly also lost.

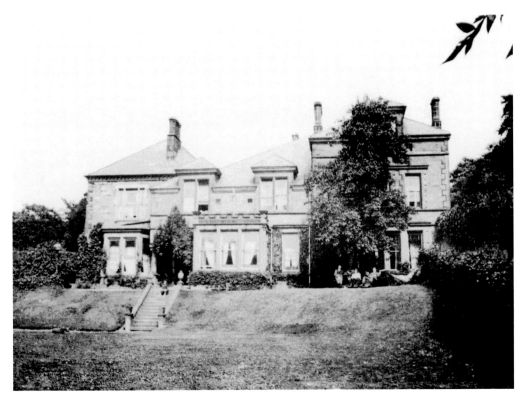

The Hermitage.

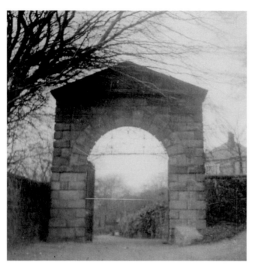

The Hermitage, classical gateway.

Herrington Hall, Middle Herrington

The cellars of Herrington Hall in Middle Herrington dated from 1570. Above ground the house in its final form was built at the end of the eighteenth century, probably after the Robinsons (its holders since Tudor times) sold it to William Beckwith in 1795. The Robinson fortune came from malting and the Robinson daughters married Robert Surtees, the historian, and a son of the poet Robert Burns.

A later Beckwith, General William, moved to Silksworth House, which had been inherited by his wife, Priscilla Hopper. On the general's death the estate passed to his nephew, after whose marriage it passed through various hands before being

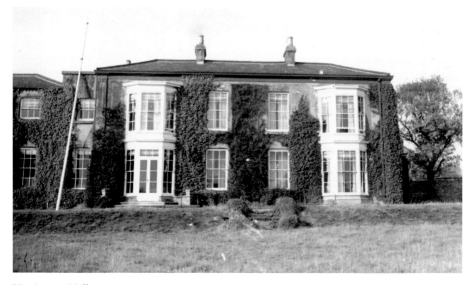

Herrington Hall.

bought by the Earls of Durham. It was let, or occupied by the earls' colliery manager, throughout the remainder of the nineteenth century. In the first half of the twentieth century it was tenanted by members of the Vaux family of brewers. The last occupant was a local builder, Harry Bell. In 1947, the Miners Welfare Commission bought Herrington for use as a rehabilitation centre, a purpose for which it was never used. The National Coal Board demolished Herrington in 1957, at which time the sixteenth-century cellars were exposed. The stables survive.

Hetton Hall, Hetton-le-Hole

The Hetton Hall estate was bought in 1686 by John Spearman. His grandson, also John Spearman (d. 1746), sold it to the Nicholson family, rich from local collieries. Jean Nicholson married Thomas Lyon, sixth son of the 4th Earl of Strathmore. Following the deaths of his elder brothers, the 5th, 6th and 7th Earls, Thomas became 8th Earl in 1735. Thomas's son John, 'the beautiful Lord Strathmore', was the first husband of Mary Eleanor Bowes of Gibside. By 1834 Hetton was deserted. However, in 1857 it was the seat of Nicholas Wood, a mining engineer. Based on later photographs it appears likely that Wood rebuilt or radically redesigned the house. By 1902 it was once again unoccupied and after a period of dereliction it was demolished in 1923. A public park was created on the site.

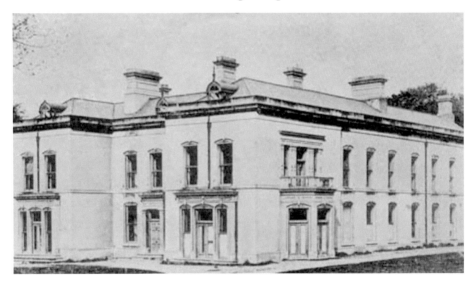

Hetton Hall.

High Barnes, Sunderland

In medieval times a property of the Dalden family, High Barnes passed to the Bowes and from them to the Barner families. The Ettricks lived at High Barnes until at least the 1850s whereafter it was tenanted. The house was later rented to the Little Sisters of the Poor and the original hall was replaced by a much larger building which remains in use as a nursing home. High Barnes was in its last

incarnation a small square classical box with three bays on the entrance front and five to the sides. There was a prominent Venetian window over the door, the central bay being set slightly forwards and having a triangular pediment with a small window. There was a rather ugly glass porch with a sloping roof up to the front door.

Holly House, Gateshead

A rather grand, if severe, three-storey five-bay building, Holly House was one of the oldest in Gateshead. It was probably built in the early seventeenth century and altered in the late eighteenth century and remained a private house until it was bought by the City Council in the early twentieth century. Its occupiers included Henry Clapham, a ship broker, Mr E. Turnbull and Mr T. Armstrong. Holly House was abandoned in 1971 and later demolished despite a local campaign to preserve it.

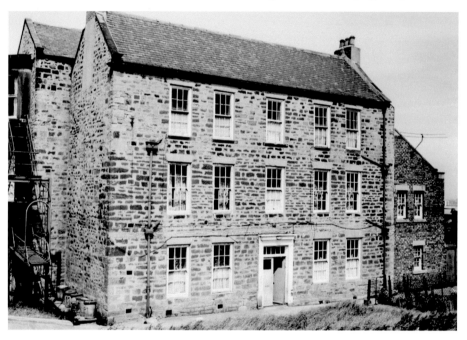

Holly House.

Hoppyland Hall (Hoppyland Park), Hamsterley

Hoppyland was a sixteenth- and seventeenth-century house largely destroyed by fire in 1793 and later restored and converted into a mock castle with pasteboard Gothic details including battlements and several small towers. An old estate belonging to the lords of Witton, Hoppyland passed to the Blacketts, who owned the estate from 1619 to 1768 when it was sold by John Blackett to George Blenkinsopp. The house remained with the Blenkinsopps and their descendants until the 1920s when it was sold to Thomas Dowling, a Bishop Auckland solicitor. Hoppyland Hall was gutted by fire in 1952 and is now a shell.

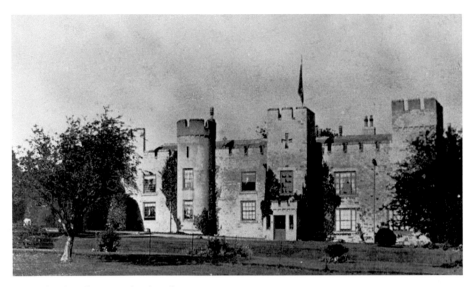

Hoppyland Hall (Hoppyland Park).

Houghall Hall, Durham

Houghall Hall was a sixteenth-century moated manor house latterly used as a farm before it was demolished in 1966. It had a seventeenth-century wing with mullioned and transomed windows under square hood moulds. The main chimney had a secret chamber and there was a Jacobean staircase.

Bishop Flambard gave the property to William FitzRanulf, whose great-grandson donated it to Prior Richard de Hoton towards the end of the thirteenth century. De Hoton is believed to have built a hall at the end of the thirteenth century. The Rackett family rented Houghall from 1464 until the Dissolution when it was sold to Viscount Lisle. The house was rebuilt as a moated manor house in the seventeenth century by the Parliamentarian Marshall family.

Houghall was returned to the Church in 1660 and in 1836 it was transferred to Durham University. In 1919 Durham County Council purchased Houghall for use as an agricultural school and training farm. Oliver Cromwell is believed to have stayed at Houghall as a guest of the Marshall family.

Hylton Lodge, Sunderland

A house by Dobson for Thomas Hughes, Hylton was demolished in 1967 to make way for a housing development.

Langley Hall, Langley Park

A huge courtyard house, now in ruins, the present Langley Hall was built in the early part of the sixteenth century by Henry Scrope. In the early twelfth century the estate belonged to Arco, steward of the bishop of Durham. It later passed through the Lisles and Percys before coming to the Scropes in the 1300s. After the Scrope line ended in 1630, later owners included the family of the Marquis of Winchester and then, in the eighteenth century, the Lambtons, but the hall itself

was ruinous by this time. Part of the building was used as a farmhouse as late as the early nineteenth century.

The ruins consist of what remains of two ranges on the opposite sides of a courtyard 75 feet across. The remains of a moat also survive.

Leechmere House, Sunderland

Leechmere was an unattractive mid-nineteenth-century house in ashlar which was probably built by the shipbuilder James Hutchinson. The entrance front had five bays, the middle three set well back under the eaves connecting the projecting outer bays. There were two double-height square bays on the garden front with a connecting balcony at first-floor level. Leechmere was later acquired by the Taylor family who used it when visiting their collieries in the area. It was also used as a residence by their mine manager. In the 1940s, Leechmere became a home for aged miners. It was demolished in 1960.

Little Usworth Hall, Washington

Little Usworth Hall was a medieval manor house which stood near Manor House Farm between New Washington and Usworth Colliery. It was the seat of the Lawson family and was demolished around 1910, by which time it was unfit for habitation.

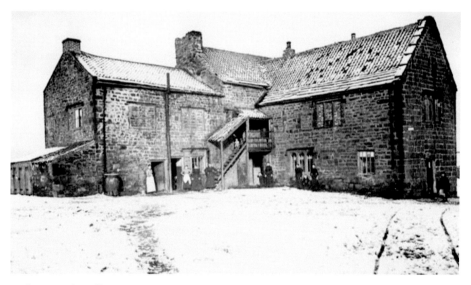

Little Usworth Hall.

Low Barnes (Barnes Park, The Barnes), Sunderland

Le Barnes is first mentioned in the historical record in 1351. The Wardell family owned it in the seventeenth century. Towards the end of the fourteenth century it passed by marriage from Jordan de Dalton to the Bowes family, who owned it until 1673. In the seventeenth century the estate was divided into High and Low Barnes, the latter being the probable site of the medieval manor. Having passed through various hands, Low Barnes was bought by the Pemberton family in 1783.

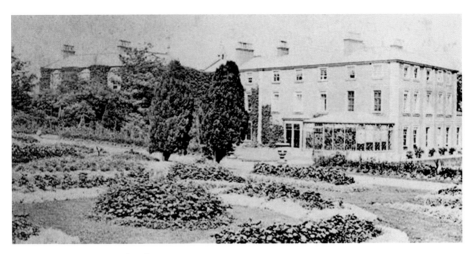

Low Barnes (Barnes Park, The Barnes).

By the end of the nineteenth century the Pembertons were no longer resident, having moved to Hawthorn Tower and the house was let to a laundry company before being sold. A Mr Punshon sold the estate to Sunderland Council in 1904 for £8,500 and Barnes Park was laid out between 1906 and 1907. The house, demolished in 1921, was a substantial classical brick house. It has been attributed to Thomas Moore. After its demolition a bowling green was laid out on the site.

Mainsforth Hall, nr Sedgefield
The oldest part of Mainsforth Hall dated from the early seventeenth century, when it was a seat of the Huttons. It belonged to the Surtees family from 1708 after it was sold by the Huttons to Robert Surtees of Ryton and Edward Surtees of Crawbrook. The latter almost completely rebuilt the house in the 1720s, adding the large three-storey five-bay block which dominates surviving images. Robert Surtees was a distinguished local historian and author of the four-volume *The History and Antiquities of the County Palatine of Durham*. After his death in 1834, his books, manuscripts and pictures were sold to clear his debts. His widow Anne lived on at Mainsforth until her death in 1868 when she was succeeded by Charles Freville Surtees of Redworth Hall. He was followed by Sir Herbert Conyers Surtees. After the Second World War, the house fell into decay. It was empty by 1952 and was demolished in 1962. It has been replaced by a modern house. The gatepiers of the old mansion, brought from Embleton Hall, survive.

Mid Hall, Widdrington
Mid Hall was the early seventeenth-century seat of the Salkelds. It was demolished in the early nineteenth century.

Moorhill, Sunderland
Moorhill was built in around 1860, probably for the Wood family, and looked like a Victorian suburban villa on steroids. The Woods remained in residence

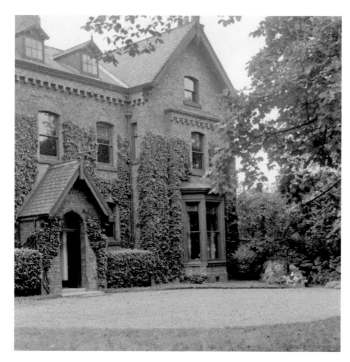

Moorhill, Sunderland.

until 1899 when Stephen and Mary Louisa Robson, owners of a local flour mill, bought it. Mary Louisa died in 1945 and the house was acquired by Sunderland Corporation for use as a remand home and later a boys' orphanage. Moorhill was demolished in the late 1990s and new houses were built on the site.

Neasham Hall, Neasham

The core of Neasham was an eighteenth-century house which was considerably extended between 1834 and 1837 by John Dobson for Colonel Cookson, member of a prominent local family of industrialists. Dobson added two large wings to either side of the earlier building and embellishments which left the house with a vaguely Elizabethan appearance.

The Lawsons acquired the lands at Neasham, which had belonged to a religious house, at the Dissolution. The estate was purchased in 1698 by Charles Turner of Kirkleatham from Sir William Blackett. The Turners held Neasham until Sir Charles Turner (1773–1810) sold it to William Wrightson who in turn sold it to Colonel Cookson. By the middle of the nineteenth century the success of the Wrightson ironworks allowed Thomas Wrightson to buy the estate back and it remains in the hands of his descendants. In 1902 Wrightson added a music room and in 1909 built a bridge over the Tees to allow him to reach the church at Eryholme. He was created a baronet in 1900.

On his death, the hall passed to his son Sir Thomas and in 1950 to his grandson Sir John, who demolished the old house which was far too large for modern living and not architecturally distinguished, commissioning a new house from Sir Martin Beckett. Neasham is now the seat of Sir Mark Wrightson, 4th Bt.

The area around Neasham Hall is the haunt of the headless Hobgoblin of Neasham, Hob Hedeless. This evil spirit is said to have lured people to a watery grave in the nearby River Tees. Following the drowning of Robert Luck, a distinctly *un*lucky Darlington bricklayer, in 1722 the hobgoblin was exorcised and buried under a large stone upon which no one might sit for fear of becoming permanently stuck.

Nettlesworth Hall, Nettlesworth
Nothing now remains of Nettlesworth Hall. In the fourteenth century it was the seat of the Gategang family before it passed to the Hagthorpes and Wessingtons. In the early nineteenth century it was the seat of the Askews.

Newton Hall, Durham
Newton Hall was restored or rebuilt around 1730 for Sir Henry Liddell, later Lord Ravensworth (Ravensworth Castle). The Liddells had acquired the manor from the Blakistons in the 1660s. It was a brick house of seven bays with fluted pilasters to the middle three bays, supporting a frieze and cornice. An attic storey was added to the house in 1751 but Ravensworth Castle was increasingly the focus of the Liddells' activities and in 1812 Sir Thomas Liddell sold Newton to William Russell of Brancepeth who offered it for rental. In 1834 it was the residence of Henry Spearman, recorder of Durham, and Sir Julian Byng lived in Newton Hall for two years after buying the property in 1909. It next became a county lunatic asylum and was a barracks during the First World War. After the war it was empty and increasingly derelict. It was demolished in 1926 and a housing estate, once the largest in Europe, covers the site.

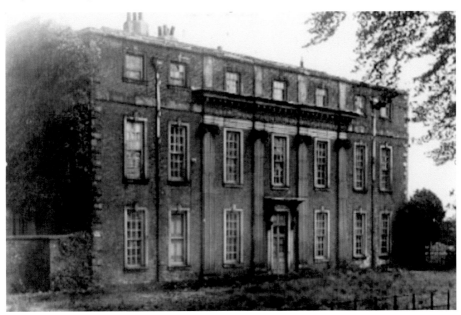

Newton Hall.

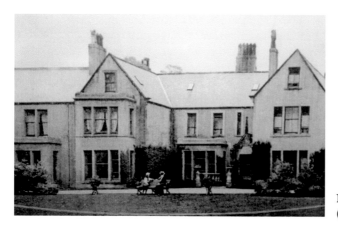

North Biddick Hall
(Cooks Hall).

North Biddick Hall (Cooks Hall)

North Biddick Hall was a house of a number of periods from the sixteenth century onwards. Particular features of the house included eighteenth-century panelling and elaborate ceiling decoration. The estate belonged to a number of families including the de Biddicks, for whom it passed to the Hyltons of Hylton Castle, the Carrs of Cocken Hall and the Davisons. In the second half of the nineteenth century North Biddick belonged to Joseph Cook the ironfounder, who renamed and may have rebuilt it. It remained in his family until it was demolished. The hall, which was originally built by succeeding generations of Hyltons, was demolished in 1966 having fallen victim to mining subsidence, to make way for the expansion of Washington New Town. The rose garden was said to have been haunted by the ghost of a young girl from the family at the hall who fell in love with a gardener from whom she was forced to part as he was not a suitable match.

Old Park, Whitworth

Old Park was the seat of the Wharton family from the time of John Wharton of Winston (d. 1628) after the death in 1587 of the last of the Claxton family whose

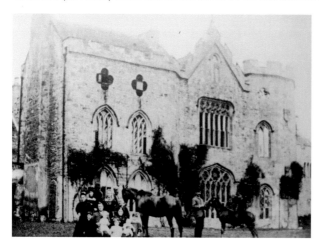

Old Park.

home it had previously been. Thomas Wharton (d. 1794) made extensive additions in the Gothick style in the 1760s, adding a semi-octagonal entrance hall, drawing and dining rooms and a new staircase. Robert Wharton, son of Thomas, succeeded to Grinkle Park, taking the name Myddleton. After this, Old Park was usually tenanted, although it was occupied by Robert's daughter Sophia and her husband, Robert Grey, vicar of Whitworth (and later Bishop of Cape Town), between 1834 and 1845.

Whitworth Park Colliery opened near the hall in the 1840s, which was at one time occupied by the colliery manager, Mr Robson. In 1868 the estate was sold to the Ecclesiastical Commissioners by the trustees of Richard Wharton Myddleton. The Commissioners demolished the house in 1901. Prior to its demolition, the hall had been used for agricultural storage. Architectural features from it were used in a new farmhouse. Thomas Gray, author of the *Elegy in a Country Churchyard*, was a friend of Thomas Wharton and a frequent visitor to Old Park.

Pallion, Sunderland

The last house at Pallion dated from the nineteenth century. John Goodchild owned Pallion in the early nineteenth century and on his bankruptcy in 1815 it became the property of the brewer and glassmaker Addison Fenwick. Pallion was the birthplace of Sir Joseph Wilson, inventor of the electric light bulb. From the 1840s until around 1900 the property was occupied by Christopher Mailing Webster and his family. The Websters made a fortune as rope manufacturers, Christopher leaving £1,200,000 in his will of 1894.

After its demolition in 1901, the staircase and other interior features were removed to Unthank Hall in Northumberland. The site passed into industrial use. Pallion is a contraction of Pavillion, first recorded in 1328 as *le Pavylion*, the summer residence of the lords of Dalden.

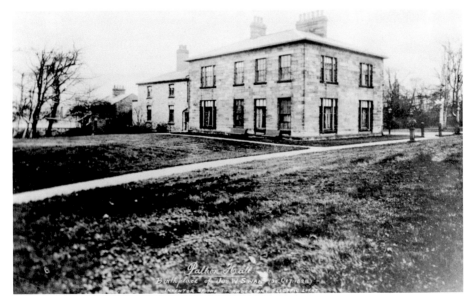

Pallion.

Park Head Hall (formally Derwent Villa), Winlaton

Park Head Hall was built in 1836 in the Elizabethan style. It was the seat of the industrialist George Heppel Ramsey (1790–1879). He was succeeded by his son John T. Ramsey and grandson G. R. Ramsey. The date of its demolition is unknown.

Ravensworth Castle, nr Gateshead

At Ravensworth (Ravenshelm) in 1080 a man named Eardwulf is said to have risen from the dead to predict the death of Walcher, the Bishop of Durham. His prediction came true after Walcher, suspected of the murder of Liulph of Lumley Castle, was murdered by an angry mob. The first Ravensworth Castle was built after the Norman Conquest by the FitzMarmaduke family, the lands having been granted by the then Bishop of Durham, Ranulph Flambard, to his nephew Richard FitzMarmaduke. The old castle, fragments of which remain, was probably rebuilt in the reign of Henry II. Buck's engraving shows four towers around a courtyard.

The last male FitzMarmaduke was killed in a brawl with his cousin on Framwellgate Bridge in Durham and the property passed by marriage to the Lumleys in 1318 from whom, again by marriage, it came to the Boyntons and then the Gascoignes. After almost 200 years of Gascoigne ownership, Sir William Gascoigne sold the castle in 1607 to his wealthy brother-in-law, the Newcastle merchant Thomas Liddell. The next Thomas Liddell was created a baronet by Charles I for his support during the Civil Wars.

The Liddell family built a large house within the castle ruins in 1724 which was later altered and improved, with some Gothic detailing by Lord Leicester and James Paine. In 1728 Henry Liddell, 4th Bt, was created Baron Ravensworth. On his death without issue the baronetcy passed to his nephew Henry George Liddell, an explorer who installed two Lapland girls in the castle and reindeer in the park. Henry George's son Sir Thomas demolished the 1728 house in 1808 except for two medieval towers which were incorporated into the stable yard.

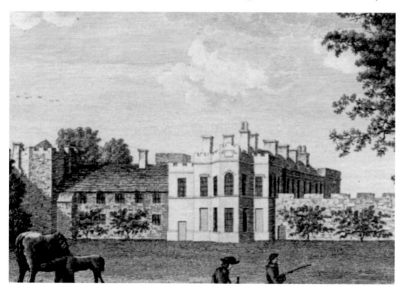

Ravensworth Castle, the Liddells' new house (1724).

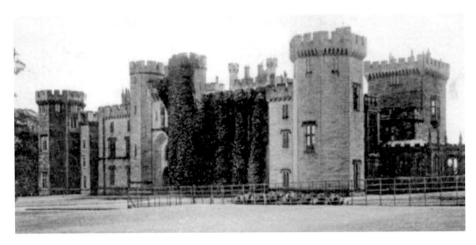

Above: Ravensworth
Castle, entrance front.

Right: Ravensworth
Castle interior.

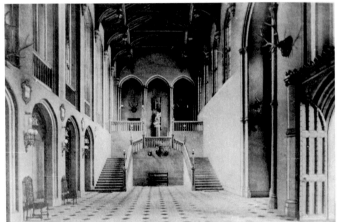

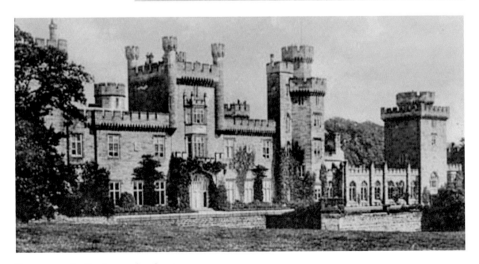

Ravensworth Castle, garden front.

Sir Thomas commissioned John Nash's superb castle and was later created Lord Ravensworth of the second creation. His considerable fortune was based on coal, but he was also the financial backer of George Stevenson, the railway pioneer, who named a locomotive *The Lord*. The castle was extended after Ravensworth's retirement from politics in 1833 and finally completed around 1846. The interiors and external massing demonstrate how skilled Nash could be when working outside his more typical classical manner. The 3rd Lord Ravensworth was created Earl of Ravensworth but died without issue when the earldom became extinct. The 5th Lord Ravensworth died in 1919 and in 1920 a sale of pictures, including a Rembrandt, and the remaining contents of the castle took place. The 6th Baron moved to Eslington Park in Northumberland, where the current baron is still seated, and Ravensworth became a girls' school. The 7th baron decided to demolish the castle and build a model village. By this time the house was suffering from the effects of mining subsidence. Lord Ravensworth died in 1950 before the model village could be built. His successor demolished the castle between 1950 and 1953. The Liddells owned the Ravensworth estate until 1976.

The castle was entered through a grand entrance between two turrets, which led directly into the great hall. At the end of the hall, the stair rose in two flights to an arcaded landing with a statue of St George and the dragon. Parallel to the entrance front and behind the long axis of the hall was a narrow corridor under an arcade, and beyond that a top-lit picture gallery stretching the full length of the main block. The state rooms along the south front opened off the picture gallery.

Fragments of the stable block survive with nineteenth-century Gothic details and the remains of the two genuinely medieval towers. A castellated gateway and lodge stand forlornly alongside the A1. A late nineteenth-century lodge by Dunn and Hansom also survives. The demolition of Nash's superb Ravensworth was one of the most grievous losses County Durham has suffered.

Lewis Carroll is said to have written parts of *Alice in Wonderland* at Ravensworth, the inspiration for Alice being Alice Liddell.

Ray House, Kirkwhelpington

Sir Charles Parsons, engineer and inventor of the steam turbine, and his wife, Katherine, moved to Ray and its 20,000-acre estate from Holeyn Hall in the early years of the twentieth century. Ray Hall was demolished in 1945.

Red Hall, Haughton-le-Skerne

Tradition states that Houghton was the scene of a battle between two tribes, one of giants. A skeleton 6′ 4″ tall with enormous teeth (!) was said to have been found there more than 200 years ago. The remains of a moat and a tumulus, said to be the burial place of those who fell in the battle, survive.

The medieval owners of Haughton were the Scropes and the Pudseys. By the mid-seventeenth century the manor was Lambton property, from whom it passed to the Chaytors. In 1697 the Chaytors sold Red Hall to Robert Colling of Long Newton.

In the 1920s the hall was bought from the Collings by the Haggie family. In 1965, Darlington Council bought the derelict hall and estate for £35,000. The estate was used for housing development. Red Hall survived, abandoned and decaying, until 1984.

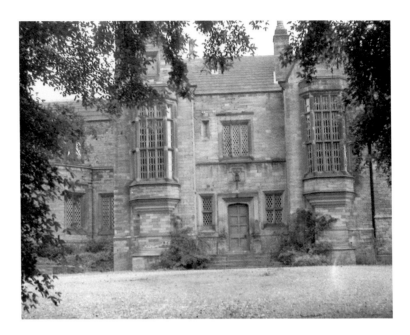

Red Hall.

Redheugh Hall, Gateshead

Never was the site of a country retreat more effectively obliterated that that of Redheugh Hall, an ancient house of the Prince-Bishops of Durham on the banks of the Tyne, held from the thirteenth century by the Redheugh family. It passed to the Whites, and in 1619 to the Liddells, who sold it to the Earl of Derwentwater. It was bought in 1748 from Lady Mary Radcliff by Adam Askew, a Newcastle physician, as a residence for his son Henry. Although the Askews owned the estate until the 1890s, it was often tenanted.

The house in its final form dated from the late seventeenth century. Two wings were added in the eighteenth century, when the house acquired a pedimented doorcase.

The Newcastle and Carlisle Railway was built between the house and the river in the 1830s. In 1835 Adam Askew (grandson of the house's purchaser) let the house to the Newcastle glass manufacturer William Cuthbert and moved to the south. The estate was put up for sale in 1850 (the course of the railway had been moved in 1839) but remained unsold until 1871 when the opening of the Redheugh Bridge made land south of the river more accessible. A Gateshead factory owner, George Hawks, Gateshead's first mayor, used Redheugh as a country retreat in the middle of the nineteenth century, something almost impossible to imagine given its location today. Much of the estate was subsequently sold and the hall was left empty or used as a storehouse; it was later bought by the Redheugh Colliery Company. The house, which stood 200 yards west of Redheugh Bridge, was gutted by fire in 1920 and demolished in 1936.

Red House, Etherley

Red House was a seat of the Stobart family, mine owners, who leant the house to be used as the 17th Durham Voluntary Aid Hospital during the First World War.

Ryhope Hall, Sunderland

Probably first built in the seventeenth century, Ryhope in its final form dated from several different periods and was dominated by a plain-brick tower with an oddly proportioned Venetian window at the top of each face. According to tradition, the tower was bult to allow a young lover to see over a wall built by the protective mother of a young lady at a nearby house, her aim being to screen her daughter from the prying eyes of her socially unacceptable young man. The house bore the coat of arms of the Booth family.

Edward Dale lived at Ryhope between 1828 and 1861. The mining engineer Major Hugh Streatfield moved in in 1889 and lived in the hall until the 1920s. Ryhope opened as a miners' welfare centre in 1933 and after a period of use by the Boys' Association it was damaged by fire in the 1950s and was demolished a decade later.

Ryton House, Ryton

Ryton was the seat of the Humble family in the eighteenth century. Joseph Lamb (d. 1800) married the heiress of the Humbles and their son Humble Lamb (d. 1844) inherited the estate. He was succeeded by his son and grandson. Joseph Lamb owned it in 1896.

Ryton was a brick house built in the eighteenth century. The main front had two storeys, the sides three. At the corner there were Venetian windows, two on the main front and two with a Diocletian window above on the side. A bay window was added to one side in the nineteenth century. In the twentieth century the entrance was covered by a small greenhouse. In later years the house was used as a conservative club, but it was demolished in 1960 and replaced by a housing estate. During Humble Lamb's occupancy, petty sessions (magistrates' courts) were held in Ryton House's Court Room.

Saltwell (Old) Hall, Gateshead

Saltwell Hall on the Saltwellside estate was in the Team Valley, now ravaged by industrial and retail units. The estate is mentioned in documents from the early

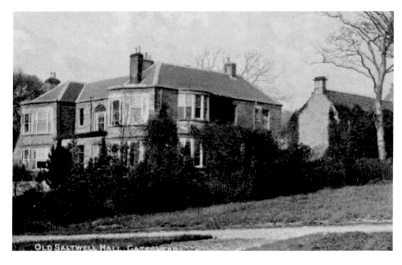

Saltwell (Old) Hall.

fourteenth century and there was a house on the site from the late 1500s. In the late sixteenth century the property was owned by the Hedworths of Harraton, in the seventeenth by the Halls and Maddisons. In 1750 it passed to Joseph Liddell of Carlisle and in 1792 it was purchased by Joseph Dunn who retained the hall and 110 acres, selling the remainder. After 1850 the hall was occupied by Charles Bulmer of the Tyne Iron Company followed by the soap and candle manufacturer Thomas Hedley and from 1893 by a local brewer John Rowell, whose widow was the last to occupy the house. In 1903 further land was sold for use as Saltwell Cemetery and the hall became an isolation hospital. Saltwell Hall was demolished in 1936.

Sherburn Hall, Sherburn
Sherburn Hall was a rather delightful small Gothic house with corner turrets and prominent machicolations. The centre bay of five, which contained the entrance, formed a stumpy tower. Residents included the Tempest and Pemberton families. The last resident was a local general practitioner who used the ground floor as a surgery. Following use for Civil Defence during the Second World War, the hall fell into decay and was demolished in 1952.

Sheriff Hill Hall, Gateshead
Sherriff Hill was a stylish ashlar villa of three bays with a recessed entrance and an Ionic porch in antis. It was built around 1828 for Revd Matthew Plummer – an attribution to John Dobson is plausible given the quality of the building and its location. Plummer died in 1856 and the house was sold. Later residents included C. F. Lloyd and John Ash. From the 1940s until 1963 Sherriff Hill was part of Gateshead High School. In 1964 it was purchased by the local council from a property developer and in 1967 it was demolished. The service wing and other fragments survive.

Sheriff Hill Hall, Gateshead.

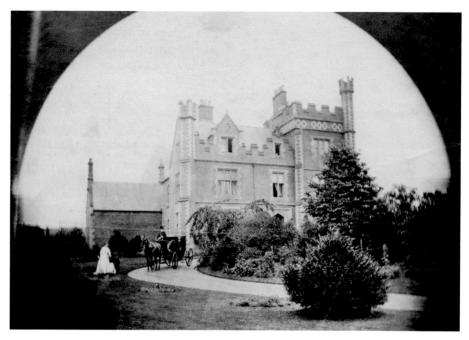

South Dene Tower.

South Dene Tower, Gateshead

Built in red brick with white-brick details, machicolations and turrets, South
Dene Tower was a charming castellated confection built by W. Carr around
1850. Within a few years Carr had sold the property to William Wailes, who in
turn sold it to John Redmayne in 1865. The Redmayne family, whose fortune
came from their chemical company, lived in some style at South Dene until 1890
when it was sold to the Newcastle merchant and collector of armour Robert
Clephan. Clephan sold the estate to George Collins in 1918 and in 1922 it was
offered for sale to Gateshead Corporation. The corporation's offer was turned
down and Collins remained in residence until his death in 1937 when South
Dene was conveyed to the corporation. The house was damaged when in use
as an ARP centre during the Second World War and after a brief period of use
as flats was demolished in 1956. The house is said to have a model for William
Wailes' neighbouring Saltwell Towers, which survives, albeit much altered
internally.

Stella Hall, Blaydon

Originally a Benedictine convent, Stella was acquired by the Tempests, a dynasty
of Newcastle merchants, in the late sixteenth century. The house was built around
1600 by Nicholas Tempest. The main façade had a recessed five-bay centre and
one-bay projecting wings. At the rear there was a long range with mullioned
windows. The Tempests were Catholic and the house was said to contain a
number of 'priest holes'.

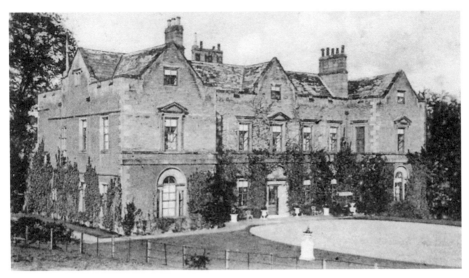

Above: Stella Hall.

Right: Stella Hall, interior.

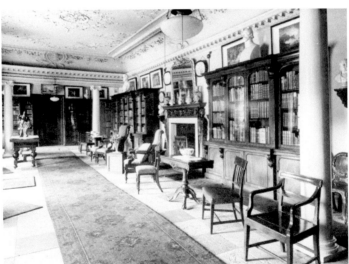

Jane, sister of Sir Francis Tempest (d. 1698) married the 4th Baron Widdrington. Widdrington, who joined the '15 Rebellion, was sentenced to death and his lands confiscated. He was later pardoned and his lands were returned in 1733. He died in 1745 and was succeeded by his son.

The house was partly remodelled by James Paine for the 5th Lord Widdrington in the middle of the eighteenth century when two Venetian windows were inserted in the wings and pediments were added to the first-floor windows. At the same time, a hall with columned screen, Rococo drawing room and Doric-columned library were created.

On the death of Widdrington in 1774 the estate passed to Peregrine Townley of Townley Hall, Burnley, and the hall was usually tenanted. In 1850 the estate

was sold to the industrialist MP and newspaper proprietor Sir Joseph Cowan (1800–73). He was succeeded by his son (also Joseph), who died in 1900. The younger Joseph's daughter followed him. On her death she bequeathed Stella to the University of Durham. It was demolished in 1953 and replaced by a housing estate. The remains of a summer house and the gardener's cottage survive. Garibaldi was a guest at Stella Hall and the head from a statue of him, found in the garden of a house on the estate, can now be found in Blaydon Library.

Streatlam Castle, Barnard Castle

Streatlam was leased by Bishop Ealdhun of Lindisfarne to the Earls of Northumberland, Aethelred, Northman and Uchtred, in 995. By the thirteenth century it had passed through the Balliol family and by marriage to the Traynes. In the early fourteenth century Alice Trayne married Adam de la Bowes, beginning a 500-year association which only ended in the twentieth century. The Bowes family are descended from Fulco de Bowes who superintended the construction of Bowes Castle in the time of Henry II. William Bowes rebuilt Streatlam around 1450 and Sir George Bowes (knighted in 1558) gained local notoriety for his savage suppression of the Rising of the North.

The castle was largely rebuilt by William Blakiston Bowes, to impress his wife, between 1717 and 1720. In its final form the new building was smaller than the original castle, which must have been a substantial building. Parts of the older building were incorporated in the new one, which was essentially only one room deep. The yett or iron door to the original cellars is now in the Bowes Museum. It was later remarked that 'nothing but veneration for the ancient seat of the family could induce Sir William Bowes to erect such a mansion in so ineligible a situation'.

George Bowes succeeded to Streatlam in 1721 but he preferred to live at Gibside and St Paul's Walden Bury in Hertfordshire. His daughter Mary Eleanor married

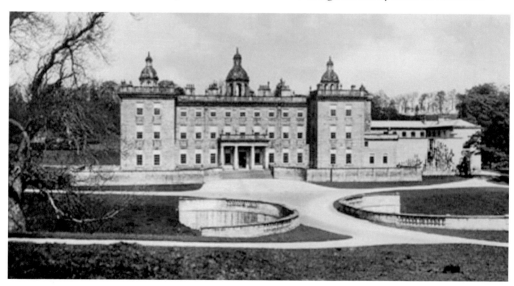

Streatlam Castle.

the 9th Earl of Strathmore and on his death, Andrew Robinson Stoney. Their appalling marriage is described in the entry on the family's other local property, Gibside. In 1786 Streatlam was the scene of an extraordinary siege by Strathmore tenants and law officers demanding the release of the Countess, who had been kidnapped by her husband and spirited away to Streatlam in order to prevent her giving evidence in her divorce hearing. Unfortunately, Mary Eleanor had already been removed from the castle in a bid to reach Ireland.

Whilst staying at nearby Raby, J. M. W. Turner visited and drew Streatlam Castle. For much of the nineteenth century the castle was home to John Bowes, illegitimate son of the 10th Earl of Strathmore and founder, with his French wife Josephine, of the Bowes Museum in Barnard Castle. Bowes' father married his mother on his deathbed but following a protracted legal battle, Bowes was permitted to inherit only the family's English estates. Nevertheless, these estates amounted to more than 60,000 acres with an annual income of £37,725 pounds (more than £3.5 million in today's values). The Scottish estates and the earldom went to his uncle and Bowes' claim that under Scottish law his parents' marriage had legitimised him was overruled as he had never lived north of the border.

The castle was significantly altered by John Bowes, some of the work being by the architect of the Bowes, Jules Pellechet. Bowes' alterations included the cupolas on the main facade and the portico. Bowes was a major racehorse owner, winning the 2000 guineas three times and the Derby four, and a memorial to his racehorse Western Australian, winner of the Derby, 2000 Guineas and St Leger, survives on the estate. His winnings made him even more wealthy – income which supported his collecting and ultimately enriched the Bowes Museum. During John Bowes' tenure the castle and estate were regularly open to the public, including to groups from nearby Barnard Castle, such as the Wesleyan Sunday School. John and Josephine remained childless, enriching instead the small market town nearby with their French-style museum which contains many of the contents of the castle. Streatlam's important collection of horse pictures has been largely dispersed, although some remain at Glamis Castle, the Scottish seat of the Earls of Strathmore.

On Bowes' death, the estates passed to his cousin the 13th Earl of Strathmore, who described the castle as 'awkward and unsatisfactory'. The estate was sold by the Earl in parcels between 1922 and 1927 (when the castle was gutted) and many of the contents were removed to Glamis. The armorial ceiling from the dining room was removed to the Bowes museum. Norman and Elsie Field of Lartington Hall bought the estate and used the outbuildings as a stud. The castle was used by the army during the Second World War and demolished with dynamite by the Territorial Army in 1958. All that remains above ground of the house itself is the arch into the service courtyard, although underground is a sewer system which incorporates parts of the original castle. John Bowes' pinetum and orangery also survive. The Strathmore family still retain significant landholdings in County Durham, although these are considerably less than the acreage held by John Bowes in 1872, and the current earl has a seat at Holwick Lodge. Streatlam now belongs to the Pease family.

Thrislington Hall, Cornforth

Thrislington Hall was a late seventeenth- or early eighteenth-century double pile house demolished in 1979. In the eighteenth century it belonged to Sir Thomas Robinson of Rokeby who sold it to Henry Hopper. By 1834 it had passed to Hopper's nephew, Robert Hopper Williamson. In 1856 it belonged to Revd Robert Williamson but was occupied by Joseph Atkinson and in 1894 it was the home of William Morson. By the 1970s as Thrislington Quarry approached, it was in a state of decay, and by 1976 it was in ruins. It was offered to Sedgefield Council, but in 1979 it was demolished as irreparable.

Tunstall Court, West Hartlepool

Tunstall was designed by C. Lewis Banks, who also designed Tunstall Manor, for Sir Christopher Furness MP and was built in 1897. The mansion had a swimming pool and ballroom and the staircase and windows were decorated with motifs of the ships built in Hartlepool and of trades associated with the town. In the 1920s, the house was given by Christopher's son Marmaduke to the engineering company Richardson Westgarth for use as a sports club. In around 1950, it was acquired by West Hartlepool Council and renovated for educational use. In 2002, the council offered cheap leases to anyone who was willing to care for the building, but the scheme was abandoned in 2006 and Tunstall Court fell into dereliction before being pulled down in 2014. Two lodges, probably also by Banks, survive.

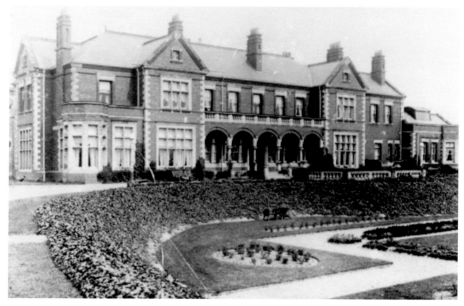

Tunstall Court.

Tunstall Manor, Hartlepool

Tunstall Manor was the fabulous home of the shipbuilder Sir William Gray who commissioned its design from T. Lewis Banks and built it in 1898. Externally it was a

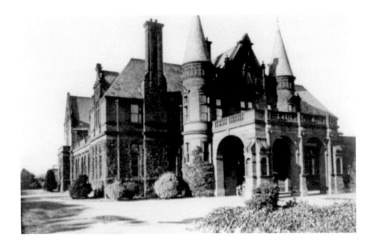

Tunstall Manor.

curious mixture of Scottish Baronial and Elizabethan with tall chimneys and a huge porte-cochere. Internally, however, its most dramatic feature was a two-storey Moorish hall with polychrome arches and pierced panels with oriel windows at balcony level.

Captain William Gray, later 1st Baronet, was already settled at Eggleston Hall in Teesdale, which his father, Sir William, the builder of Tunstall Manor, had bought him in 1919 as a present on his return from the First World War. The family didn't need both houses and Tunstall Manor was surplus to requirements. Discussions with the local council regarding purchase of the property came to nothing and Tunstall Manor was demolished in 1926. It only lasted twenty-eight years but had it survived only a few years longer it might have found new use, perhaps as a hotel and one of Hartlepool's (few) architectural highlights.

Uplands, Darlington

Uplands was built in the early 1860s by Joseph Pease for his daughter, Rachael, and was one of the huge houses which formed a Pease settlement in West Darlington, of which only Elm Ridge survives. The architect was probably Alfred Waterhouse.

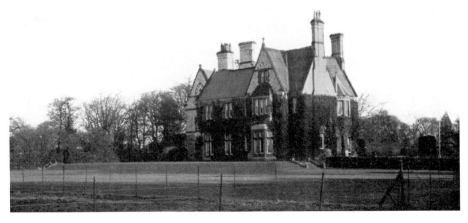

Uplands.

When Rachael moved to Gunnergate Hall, Uplands became the home of Jonathan Edmund Backhouse. Backhouse's son, Sir Edmund, was born at Uplands in 1873, and later became famous and then notorious as the Hermit of Peking, Chinese scholar, lover of the Chinese Empress and dealer in forged Chinese manuscripts. Uplands was demolished in the 1970s.

Usworth House (Peareth Hall), Washington

Usworth House was usually known as Peareth Hall to distinguish it from Little Usworth Hall and Usworth Hall. The hall was built around 1750 for William Peareth, coal owner and alderman of Newcastle for fifty years. Peareth died in 1775; his descendants occupied Usworth until the 1860s and owned it until the 1890s. Their tenants included the iron founder Thomas Bell, a decade later Samuel Bailey Coxon and towards the end of the nineteenth century a wine merchant by the name of Jonathan Bailey. The entrance front had seven bays, the middle three projecting slightly. There was a large canted bay overlooking the park, and the central block was flanked by lower, two-storey, pavilions. In the nineteenth century the hall was home to John Bailey, a wine merchant. Apart from one wing which survives as a farm, it was demolished between 1895 and 1919.

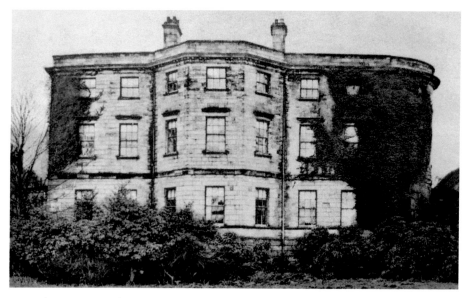

Usworth House (Peareth Hall).

Westoe House, South Shields

Westoe House was a plain eighteenth-century house of five bays which incorporated an earlier, seventeenth-century, building. It was first recorded in 1753 when it belonged to Robert Walker, who made his fortune in the Greenland fisheries boom. In 1825 the house was inherited by Robert Ingham, the first MP for South Shields. By the time Ingham died in 1875 most of the estate had been sold. In the late nineteenth century Westoe's owner was the shipowner Matthew Cay. After the death in 1943

of the last private owner, the Ingham Infirmary bought it. It was never used by the hospital, and derelict and beyond renovation, it was demolished in 1958.

Whitburn Hall, Whitburn
Whitburn Hall was the seat of the Williamson family from its purchase by Sir Hedworth Williamson in 1719 and especially after the destruction by fire in 1790 of Monkwearmouth Hall. The Williamson baronets were major local landowners, rich from the profits of their limestone quarries. All the eldest sons took the name Hedworth.

The oldest part of the house was seventeenth century. This was extended in the eighteenth century when a six-bay range was added. At the turn of the eighteenth century a grander nine-bay section was added to the end of the façade. This section was remodelled by John Dobson in 1856 when a new drawing room and entrance hall were built and again in 1881 for Sir Hedworth Williamson when a cast-iron balcony supported by caryatids was added. Above the balcony, the windows were heightened with oeil-de-boeuf windows above and a balustrade with urns.

Both the Duke of Edinburgh (Queen Victoria's second son) and the Prince of Wales were guests at Whitburn. During the First World War the hall was used as a recruitment and basic training depot and subsequently the headquarters of an anti-aircraft battery, the family having moved to their seat on the Isle of Wight in 1913. The hall's contents were sold in 1942. Whitburn Hall was gutted by fire in 1978 and demolished in 1980.

Whitehill Hall, (Southill) Chester le Street
The manor of Whitehill was first mentioned in 1310 and was the seat of the Millot (Mylote) family from the fifteenth century until the death of John Millot in 1747, when it became the residence of the Wastell family. The house was remodelled around 1830 by its then owner John Cookson. A colonnade was built in front of the old facade and wings with bay windows added at either end. The Cookson fortune came from iron forging and the nearby Furnace Farm marks the site of the first blast furnace in the world to use coke rather than coal.

The estate was still in Cookson ownership in 1858, but in 1894 it was sold to Charles Rollo Barrett. It was demolished around 1917 following subsidence from the nearby Pelton Fell Colliery and the land used for housing development. Whitehill's lodge and gates survive. A second Whitehill Hall was built in around 1920, but it too has been demolished. A lodge survives. Whitehill Estate ocument

Wolviston Hall, nr Stockton
The origins of Wolviston are unclear: it passed from Thomas Appleby to Thomas Skinner and was later occupied by Augustus Freidrichson and Wright Clunie. From the 1880s, Wolviston was the home of the Webster family who had purchased it from a Captain Young. After the death of Captain and Mrs Webster, their son moved to his other house, Unthank Hall in Northumberland. During the Second World War, Wolviston accommodated prisoners of war. After the war Wolviston was converted into flats. A Mrs Linton bought it and occupied the largest flat. After her death it was bought by developers, who demolished it and built Manor Court.

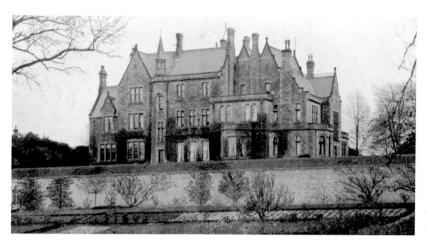

Woodburn,
Darlington.

Woodburn, Darlington

Woodburn was designed by G. G. Hoskins and built around 1870 by John Pease (son of Edward 'Father of the Railways' Pease) for his daughter Sophia. He built the next-door Elm Ridge, which still survives, for her sister Mary Anna. Sophia married the businessman, Darlington MP and philanthropist Sir Theodore Fry who amassed a considerable collection of Greek and Etruscan pottery. After his wife's death, Fry no longer lived at Woodburn and the house and grounds were bought in 1913 by the Clayhills family. The last owner of Woodside before its demolition in 1935 was Thomas Clayhills-Wilson (1836–1933). Fragments of the mansion were used in the construction of the 1930s houses which replaced it.

Woodside, Darlington

Woodside was a rather rambling Italianate villa built in 1842 for John Castle Hopkins, a Scottish industrialist and pit owner, by Thomas Robson junior. Hopkins' firm *Hopkins, Gilkes and Co.* made the steel for the Tay Bridge, which collapsed in 1878. In the late 1840s it was bought by John Harris, a Quaker civil engineer involved in the development of Middlesbrough, who added a huge conservatory designed by John Ross of Darlington. After Harris' death in 1869, Woodside became home to the widow and daughters of Gurney Pease (1839–72). One of the daughters was Katherine Pease, who became the first archaeologist to study the statues of Easter Island. During the First World War Woodside served as a military hospital. It was demolished in the 1930s. The kitchen garden and vinery survived as a market garden until 1984 but have since been built over.

Woodside Hall, Eaglescliffe

Richard Henry Appleton, Stockton flour miller and later mayor of the town, built Woodside in 1876. The hall had a prominent circular tower with a conical roof. After the departure of the Appletons, Woodside belonged to the Harrison family. It was then the wartime headquarters of ICI before accommodating the Cleveland School from 1945 to 1970. The hall was demolished in 1970 and only the entrance to the stables survives. A school now stands on the site.

Lost Houses of Northumberland

Anderson Place, Newcastle

Originally Church land belonging to the Grey Friars, Anderson Place became the property of the Newcastle merchant Robert Anderson in 1580. Anderson built himself a house, originally known as Newe House, on the site. The house was later described as a 'princely house built out of the ruins of the friars'. Charles I was held prisoner by the Scots at Anderson Place in 1646–47.

In 1675 the house was bought by Sir William Blackett, MP for Newcastle and eventually owner of Wallington, who added brick wings. In 1782 the Newcastle builder George Anderson (no relation to the builder of the house) bought Anderson Place. On the death of his son in 1831 Anderson Place was incorporated into Richard Grainger's plans to rebuild the city and it was demolished in 1834. The Andersons moved to Little Harle Tower in Northumberland. Anderson Place stood near what is now Grey Street.

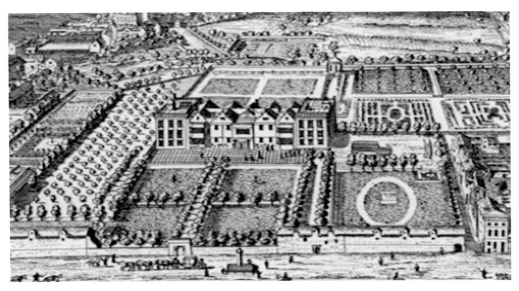

Anderson Place.

Bank House, Acklington

Bank House, demolished in 1957, was an elegant classical box of five bays and two storeys, the central bay slightly projecting and with a shallow triangular pediment. It replaced an earlier house on the site and has been ascribed to William Newton. Robert Tate, an Alnwick skinner and glover, bought a farmhouse and the land around it before 1782 and his son John built Bank House.

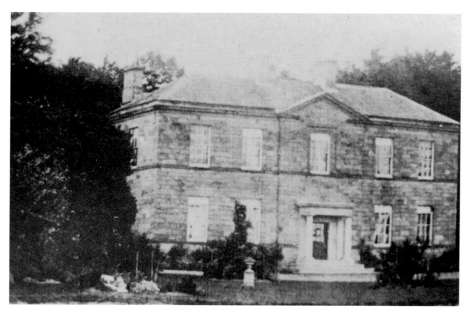

Bank House.

Barmoor Castle, Lowick

Barmoor Castle stands forlorn and derelict in the middle of a beautifully kept caravan and holiday home site. One can only hope that it might, in due course, be restored. Barmoor was granted to the Muschamp family after the Norman Conquest. They built a tower house on the site and a licence to crenelate was granted by Edward III in 1341. By the middle of the sixteenth century the castle was ruinous. Partial repairs were carried out in 1584. The estate was sold to William Carr in 1649 after the death of George Muschamp.

Barmoor changed hands several times in the eighteenth century until in 1791 it was acquired by Francis Hurt Sitwell. The Sitwells commissioned a Gothic Revival mansion on the same site as the old house and incorporated fragments of it. The architect was John Paterson of Edinburgh. The entrance front has five bays and three storeys with a central tower from which square turrets project diagonally. The garden front, which has a central two-storey, three-bay bow and round corner turrets, was a banqueting suite and is clearly a later addition. The entrance hall is oval and gave access to a cantilevered stair with an oval glass dome. Behind the stair is, or was, an oval saloon. Alterations were made by Brigadier General W. H. Sitwell in 1891. From 1899 to 1913 Barmoor was rented by Thomas Hodgkin. The Lamb family have run a holiday and caravan park on the site since 1979.

Beaconsfield House, Cullercoats

Beaconsfield was the seaside villa of John Henry Burn who built it at a cost of £35,000 in the early 1880s and named it after Benjamin Disraeli, Earl of Beaconsfield. After his death in 1898, Burn's widow occupied the house until 1922 when it was sold to Robert Thornton Bolt, a local provisions merchant.

During the Second World War Beaconsfield House was used as an anti-aircraft station. In 1946 it became a Barnardo's children's home. The house was bought by Tynemouth Council in 1953 for use as a convalescent home and demolished in 1957.

Bebside Old Hall, Bebside

A manor house existed at Bebside in the mid-thirteenth century. In 1565 monastic lands in Bebside were granted to Haber and Jenkins, from whom they passed to the Ogle family who remained in possession until the eighteenth century. The Old Hall, of which only a fragment remains, probably dated from the sixteenth and seventeenth centuries during the Ogle occupation and is likely to have incorporated a pele tower. The hall was built around a large courtyard enclosed by a service wing and stables. Later owners included the Delavals, John Johnson, Mary Fielden and in the early nineteenth century Robert Ward. The hall was occupied until the end of the eighteenth century and most was demolished in 1853, leaving only fragments which were further reduced in the early twentieth century. Traces of the moat survive.

Bedlington Old Hall, Bedlington

The oldest part of Bedlington Old Hall was a sixteenth-century pele tower with hood-moulded mullioned windows. A large, regular, three-storey block was added at some point in the early eighteenth century. By the mid-nineteenth century the hall had been divided and was a workers' tenement. It was demolished in 1959 and replaced with council offices, an act of vandalism that would now be unthinkable. The offices are no longer used and awaiting demolition in their turn.

Beech Grove, Elswick

At the time Beech Grove was pulled down in 1897 it belonged to George Angus, a leather manufacturer. It was an early nineteenth-century Tudor-style house, previously the home of Edward Richardson and his son John Wigham Richardson. In 1861 it was the home of William Mather.

Bellshill, Adderstone

When the Adderstone estate was sold off in the late eighteenth century, John Pratt bought 798 acres and the house at Bellshill. He was probably responsible for building the Bellshill mansion which was demolished in the 1940s. After Pratt's heirs sold the estate in 1830, the house had many later owners including the Selby family of Twizell. Most of the estate was sold off in the 1920s.

Benton Grange, Benton

Benton Grange was probably built for Matthew Liddell, a local colliery owner, around 1830. In 1888 it became a Roman Catholic convent providing a 'home for penitents and young girls with dangerous surroundings or who need training'. The house later became an approved school and then a community home which finally closed in 1984. Following a brief period as student accommodation, Benton Grange was demolished in 1987 and housing built on the site.

Benton Hall, Benton

Benton Hall was also known as Little Benton Hall and Benton White House. It was built around 1760 by Thomas Bigg, although the wings with canted bays were probably later additions. In 1838 Mrs James Anderson lived at Benton Hall as, later, did the banker John Antony Woods. Between 1854 and 1858 the estate was converted into a public botanical gardens. The hall was unoccupied between 1900 and 1929 and was later demolished.

Benton Park, Benton

Benton Park was a late eighteenth-century house with wings connected by curving walls to the main block. Its owners included Dixon Brown and Dixon Dixon of Longbenton. Brown's son-in-law, William Clark of Belford Hall, occupied Benton Park for a time and commissioned Dobson to survey the estate. By 1838 Benton was the home of the coal owner John Potts whose son succeeded him. In 1871 it belonged to Edward Liddell and it remained with the Liddells until the end of the century. After a period standing empty, it became a golf club after the First World War and was demolished in 1938. Benton Park was also known as Benton House, Red Hall and Benton Park Hall.

Benwell Cottage, Benwell

Although the significant number of substantial properties in Benwell hint at its eighteenth- and nineteenth-century glories, it is difficult to imagine what it must have been like as an exclusive and separate hamlet when contemplating Benwell

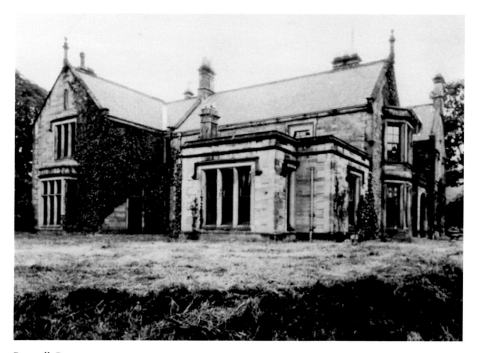

Benwell Cottage.

today. It is now an area of post-industrial decline and high levels of unemployment. Benwell Cottage was a Gothic house built in 1844 by William Hawthorne, a civil engineer. It was sold to the coal owner J. O. Scott in 1881 and from 1906 to 1924 was occupied by the industrialist Colonel William Angus. During the 1930s, most of the 9-acre grounds was sold for housing.

In 1925, Benwell Cottage became a hostel for men from the Royal Victoria School for the Blind. The remainder of the land was sold off in the 1950s. After use as a Civil Defence Corps Training Centre, the cottage was demolished 1972. Benwell Cottage stood on the south side of Ferguson's Lane near the junction with Benwell Lane.

Benwell Grange, Benwell

Benwell Grange was built between 1860 and 1863 for Benjamin Carr Lawton, a civil engineer. Later owners included the gutta-percha merchant George Angus, a relative of Colonel Angus of Benwell Cottage; the banker Ralph Brown; and J. E. McPherson. In 1907 Benwell Grange became a training school for disabled servicemen and from 1920 to 1954 it served as a girls' hostel for the Royal Victoria School for the Blind. Benwell Grange stood in 2 acres of ground off Benwell lane near Hodgkin Park Road. It was demolished in 1968.

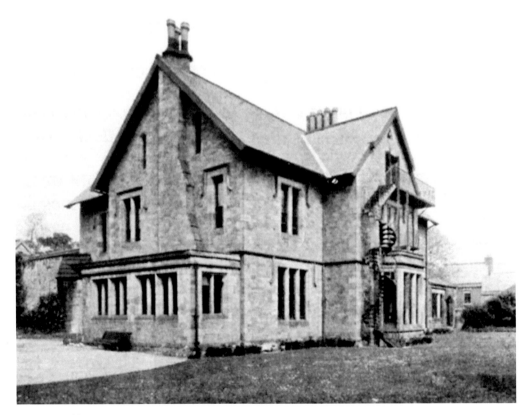

Benwell Grange.

Benwell Grove, Benwell

Designed in 1816 by Dobson for Charles Cook and occupied shortly after by Anthony Clapham, Benwell Grove was demolished around 1915.

Benwell Hall, Benwell

The original Benwell Hall was a five-bay brick house of two storeys separated by a double string course, probably built in the 1770s. The first occupant is believed to have been Auborne Surtees, who died in 1800. He was followed by William Cuthbert, who probably employed Dobson to make alterations and later commissioned him to build Beaufront Castle. In the mid-nineteenth century the property belonged to Cuthbert's business partner William Isaac Cuthbertson. Later in the nineteenth century the hall was owned by William Cookson and then the Liddell family, who bought it in 1857 and stayed until 1897 when they moved to Prudhoe Hall. After this, the hall was leased to John Burdon. In 1924 John Liddell sold most of the property to William Bramble but 5 acres were purchased by Armstrong Whitworth Ltd for use as a sports facility. William Bramble died in 1948 leaving six daughters, the last of whom died in 1980, by which time the hall was effectively derelict.

Benwell Hall was purchased by a housing association and demolished in 1982; sheltered housing now stands on the site. The original house was a neat little villa of five bays and two storeys to which asymmetrical wings were added, one of two, the other of three bays with a further nineteenth-century extension.

Benwell House, Benwell

Benwell House was built for John Walker of Wallsend in the early 1820s. In 1848 it was sold to the tanner Jonathan Priestman. It was a compact three-bay classical villa with a portico in antis and what appears to have been a later, lower, wing to one side. In 1879 it was sold to Edward Bilton and in 1901 to J. Lamb Ltd, a local brewing company who used it as the Benwell House Hotel and made additions to the original building. The hotel was closed in 1968 and the building was demolished in 1972.

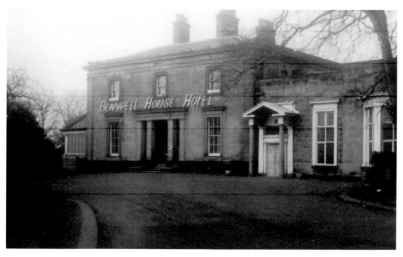

Benwell House.

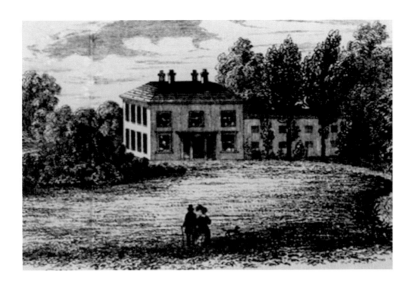

Benwell
Lodge.

Benwell Lodge, Benwell

Benwell Lodge was built sometime between 1750 and 1770 by Robert Shafto. In
the 1820s it was the seat of Robert Pearson. The lodge was divided in the 1850s
and demolished in the early 1960s.

Benwell Old House, Benwell

Not much is known about Benwell Old House; it appears to have dated from the
late seventeenth or early eighteenth centuries, although it was rebuilt in the 1830s.
Its owners included Joseph Straker (d. 1873), A. S. Carr, Ralph Cromwell Gregg
and the Thirlwell family. During the Second World War it was a children's nursery
and it was demolished in the 1950s.

Benwell Old House.

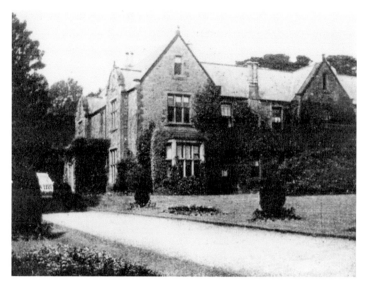

Benwell Park.

Benwell Park, Benwell

Benwell Park was built in the neo-Elizabethan style for the barrister John Mulcaster in 1852. It was sold to the shipowner Leonard Macarthy in 1914 and in the early 1930s to a local firm of builders, Haddon and Hillman, who demolished the house and built an estate of semi-detached houses.

Bewshaugh, Kielder

Bewshaugh was the seat of the Hedley family, built in the middle of the nineteenth century. Its ruins now lie under Kielder Reservoir.

Biddlestone Hall, Alwinton

The Selbys were seated at Biddlestone Hall for almost 700 years, the estate having been granted to Sir Walter Selby in 1271. The final Biddlestone Hall was built

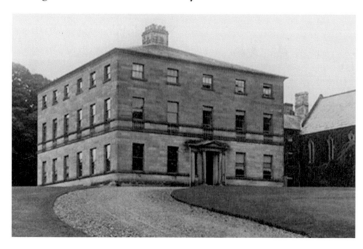

Biddlestone Hall.

in the 1790s by Thomas Selby near the site of an earlier tower house. It was a severe classical building six bays by five with a pyramidal roof and a single central chimney. In the early nineteenth century Walter Selby commissioned John Dobson to alter the house and add a chapel which was built on top of the remains of the tower house.

The Selby family left Biddlestone in 1914, although the hall failed to sell. The brewer Farquhar Deuchar lived in the hall after 1925 and the house was used as a convalescent home during the Second World War. Thereafter Biddlestone fell into decay. It was demolished in 1956 leaving only the chapel. Biddlestone is said to have been the inspiration for Osbaldeston House in Scott's *Rob Roy*.

Birtley Hall, Birtley

Birtley was built in 1843 for J. Warwick, a local colliery owner, by John Dobson. The new hall, which replaced a building dated 1692, was a low stone house of five bays, the centre three slightly projecting. The house overlooked Birtley Iron Works and many of its occupiers managed the works, including G. Skipsey in 1828, Benjamin Thompson in 1834, John Hine Hunt in 1851 and Edward Perkins in 1865. The Perkins family were involved in the ironworks from 1834 and made a number of alterations to the hall. Edward Perkins was succeeded by his son Charles and in 1906 the house was occupied by Charles Perkins' son-in-law Herbert Fenwick. Its last occupant was Henry Murton. Birtley was demolished around 1916.

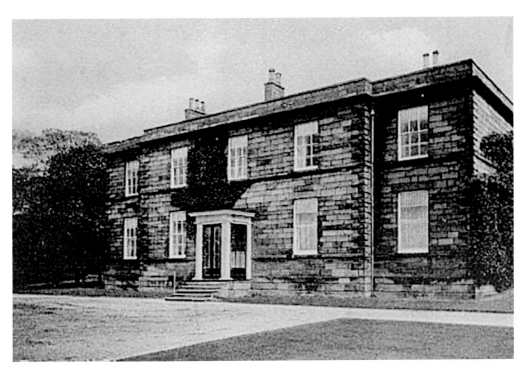

Birtley Hall.

Birtley Old Hall, Birtley
Demolished in 1961 following a fire, Birtley Old Hall was built by John Emmerson in 1692. The hall's last occupant was a railway inspector named Robert Auton.

Blackhall Hill, Simonside
A shooting box, built in around 1700 by Sir William Blackett, tradition has it that Blackhall Hill was burnt down by gypsies in 1812.

Blenkinsopp Castle, Haltwhistle
When the Normans were handing out land around Haltwhistle, there were no takers for Blenkinsopp, so it remained with its Saxon tenant called Blencan. It was held by the Blenkinsopp family from the thirteenth century and licence to crenelate was granted in 1340. Like so many local castles, its core was a square tower, in this case within a small court enclosed by a curtain wall. By the sixteenth century the castle was decaying and although the Blenkinsopps still owned it, possession was granted to the Earl of Northumberland whilst the family lived at Bellister Castle and Blenkinsopp Hall nearby. After 1727 when Jane Blenkinsopp married William Coulson of Newcastle, the property continued to decline, being used for a while as a poorhouse. John Dobson had added a Gothic mine agent's house by 1832 and between 1877 and 1880, the castle was rebuilt as a country house by William Blenkinsopp Coulson. Shortly thereafter the Coulsons sold the Blenkinsopp estates to Edward Joicey. Blenkinsopp Coulson's house was destroyed by fire in 1953. Some ruins remain and part has been restored as a house. The surviving fragments stand forlornly in the middle of a holiday park. Blenkinsopp has its own ghost story, of a white lady who wanders in search of the treasure she had hidden from her grasping husband, Bryan de Blenkinsopp.

Bonny Rigg Hall, Bardon Mill
Demolished in 1985, Bonny Rigg was a shooting box designed in 1828 for Sir Edward Blackett, 6th Baronet of Matfen, by John Dobson. The Blacketts owned Bonny Rigg until 1968. The main hall was destroyed by fire in 1985 and only the coach house, stable block and some service rooms survived. The present owners have converted the coach house into a new house.

Bothalhaugh, Ashington
Bothalhaugh was a dramatic *Addams Family*-style red-brick mansion of 1880 with an octagonal turret and multiple bays and gables. In the late nineteenth and early twentieth century the house belonged to Revd Ellis, son of Lord Howard de Walden and rector of Bothal.

Brandon White House, Wooler
The house was built by the successful Newcastle lawyer Lancelot Allgood and enlarged after 1740 by his son. Brandon White House burnt down after the Second World War.

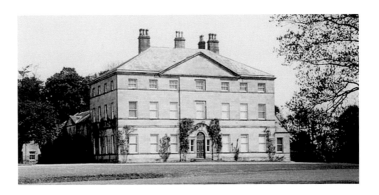

Broome Park.

Broome Park, Bolton

The Broome Park estate was bought by Thomas Burrell in 1658 and passed to his descendant Byron Burrell in 1751. The final house was probably created by Byron Burrell who occupied it until 1806; William Newton is the most likely candidate for Burrell's architect. Broome Park was a rather elegant large villa with three storeys and seven bays and a triangular pediment over the middle three. The house was altered by Dobson for William Burrell in 1829. Broome Park was demolished in 1953.

Campville, Tynemouth

Campville was built in 1814 for the shipowner John Fenwick and demolished in the early twentieth century.

Carville Hall (Cosyn's Hall), Wallsend

Cosyn's Hall was originally built in 1635 on land leased from the Dean and Chapter of Durham, for John Cosyn, a Newcastle draper who used it as his country home. The drive to the house appears to have followed the line of Hadrian's Wall. After ownership by Cosyn's daughters, the hall had various owners before Robert Carr, a wealthy silk merchant, bought the estate in the early eighteenth century, rebuilt the mansion around 1750 and renamed it Carville Hall. Carr left the estate before the end of the 1750s and again a variety of tenants followed, including Edward and Elizabeth Montagu and John Bigge, Carr's nephew. A number of the nineteenth-century tenants made alterations and additions to the house, although urbanisation and industrialisation gradually encroached on the estate. In 1873 John Richardson bought Carville and 60 acres of land which he used to expand his shipyard and build workers accommodation. By 1880 the hall had been divided into tenements and the stables and outbuildings demolished. The hall was demolished in 1898 after a fire, and terraced housing was built on the site.

Castle Hill, Haltwhistle

Castle Hill consisted of a large defensive tower with three storeys built by Albany Featherstone, probably between 1607 and 1611. A later two-storey wing was added to its east end. A previous house was mentioned on the site in the early fifteenth century. Castle Hill was altered in the late seventeenth century when the ground floor of the tower became a kitchen. It was demolished in 1963.

Chirton House, North Shields

Chirton was also known as Churton, and originally as Cheuton. In 1672 Ralph Reed sold Chirton to John Clarke, agent of the 11th Earl of Northumberland. The Countess of Northumberland gave Clarke the materials to build his new house from the ruins of Warkworth Castle. In practice Clarke's new house was to be brick built and most of the stone was newly quarried. Clarke died in 1675 and Chirton became the seat of his widow Jane and her second husband, Phillip Bickerstaffe, MP for Berwick. In 1699 Bickerstaffe surrendered his land at Chirton to Sir William Blackett, who sold the hall to Archibald Campbell, 1st Duke of Argyll.

Chirton was never home to the same family for long, later owners including Robert Lawson in 1707, the Milburns in the early eighteenth century, the Roddams and the Collingwoods, including Cuthbert Lord Collingword, Nelson's second-in-command at Trafalgar. Dobson worked at Chirton in 1819 for Michael Robson. Chirton was in ruins by the mid-nineteenth century and was demolished in 1899. The house was said to have been haunted by the former mistress of the Duke of Argyll. The sound of her silk dress was heard and the ghost was known locally as Silky. Reports of the ghost's appearance in a brown dress continued into the twentieth century and gave their name to the present Silky's Lane. Another apparition called Silky haunts Denton Hall.

Cowpen Grove, Blyth

Cowpen Grove dated from around 1750 and originally sat in extensive grounds which were gradually sold. In 1897 Charles Alderson lived at the Grove, in 1910 Christopher Baldwin and in 1910 Leopold Fothergill, a surgeon. Cowpen Grove was demolished in the 1970s.

Cowpen Hall, Blyth

Cowpen Hall was probably built in 1720 by Peter Potts, a Newcastle skinner and glover, on the site of an earlier house. Potts sold the house in 1725 to the barrister Stephen Mitford who in turn sold it four years later to Henry, son of Thomas Sidney, chaplain to Charles II from 1660. The Sidneys owned the house until the twentieth century when it had a number of owners before being demolished in 1958 to make way for urban development. A McDonald's restaurant now stands on the site.

Cowpen House, Cowpen

An eighteenth-century house of five bays and two storeys, Cowpen House was demolished around 1970 as part of an urban development scheme. In 1886 the Misses Susan and Mary Ann Sidney lived at Cowpen House, their brother living at Cowpen Hall, so Cowpen House may have been used as a dower house. A British Legion Club stands on the site.

Coxlodge Hall, Gosforth

John Bulman, who built Coxlodge in 1796, made his fortune in India. Bulman lived at Coxlodge until his death in 1818 when his son tenanted the house and moved to a smaller property nearby. He began to sell off the estate and in 1832 sold the house and about 30 acres of land to the banker John Anderson. In 1859

Coxlodge was purchased by the soap manufacturer Thomas Hedley. The house burnt down in 1877 but was rebuilt two years later by the shipbuilder Andrew Leslie who sold it to John Harper Graham in 1894.

In the early years of the twentieth century Coxlodge belonged to Rowland Hodge. Hodge and his wife were found guilty of hoarding food during the First World War, but Hodge was later made a baronet for his services during the conflict! Most of the estate had been sold by the 1930s, leaving the hall hemmed in by suburban housing. The house, which was Italianate with a prominent porte-cochere and unusual small dome over a central curved bay, survived as a school until 1939 when it was demolished. The stables and a lodge survive. The area around the estate became known as Bulman Village.

Cresswell Hall, Cresswell

The Cresswells possessed land at Cresswell as early as the twelfth century, building a tower house, which still stands, in the fourteenth. An inscription under a window of the old tower, now lost, once read 'William Cresswell, brave hero'. The White Lady of Creswell is said to be the spectre of a Saxon lady of Creswell who starved herself to death after her brothers killed her Danish lover. If she is still about, she must be the longest-established phantom in the North East. In the mid-eighteenth century a classical mansion was added to the tower by William Cresswell. The mansion was let during most of the later eighteenth and early nineteenth centuries, gradually falling into such disrepair that the classical building was demolished in 1845. During this period the Cresswells lived at Woodhorn Manor.

The male Cresswell line died out in 1781 when John Cresswell left only two daughters. Frances married Francis Easterby who bought out his sister-in-law's share of the estate and changed his name to Cresswell. Their son, Addison Cresswell, married an heiress, adding the name of her cousin, from whom she inherited substantial estates, to become Baker-Cresswell. Addison Baker-Cresswell, as he now was, built a new Cresswell Hall between 1821 and 1825. The architect was John Shaw. Like Belsay, which was obviously a model, the new hall had two columns in antis on the entrance front. The house also had a central hall, although the stairs rose to a half landing over an arch giving access to the rooms beyond, before returning to give access to the first floor. Creswell is believed to have been the model for some of Dobson's earliest villas. The garden front had a central curved

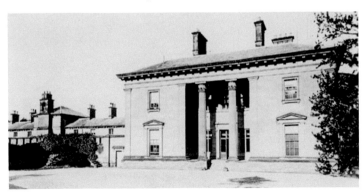

Cresswell Hall.

bay with a ring of full-height columns. The service rooms were hidden behind a curved colonnade (surviving as ruins) which connected with a conservatory.

Baker Cresswell died in 1879 and was succeeded in turn by his grandson and great-grandson who died in 1921. In 1924 most of the estate was sold and the hall left unoccupied. Cresswell Hall later passed to the Ashington Coal Company and was occupied, although already partially demolished, by their traffic manager. The house was demolished in 1938.

Dilston Castle, Dilston

The Dilston estate passed to the Radclyffe (Radcliffe) family through the marriage of the heiress Anne Cartington to Sir Edward Radcliffe. The Radcliffes were Roman Catholic, imprisoned for recusancy and accused of involvement in the Gunpowder and Popish plots. The castle was originally an L-shaped tower house, until, in 1622, Sir Francis Radcliffe incorporated it into a manor house. In 1709 James Radclyffe, Earl of Derwentwater, returned to Dilston from France, where he had been brought up with the son of James II, and began to extend the house. Inconveniently, the Earl was executed after the 1715 Rebellion and his son died in childhood, bringing the Radcliffe line to an end.

The ghost of the Earl's wife is said to haunt the castle ruins. The estates passed to the Greenwich Hospital Trust who demolished the house in 1767, leaving the tower as a roofless ruin. Tradition has it that stone from the lost house was used in the construction of the Golden Lion Inn in Corbridge.

Earsdon White House, Earsdon

Earsdon White House was once the seat of the Barkers, a long-prominent local family who took the name of Purvis on inheriting substantial estates. Earsdon White House was used as an officers' mess by the Northumberland Fusiliers during the First World War and accommodated a working men's club before it was purchased by Tynemouth Council and demolished in 1959.

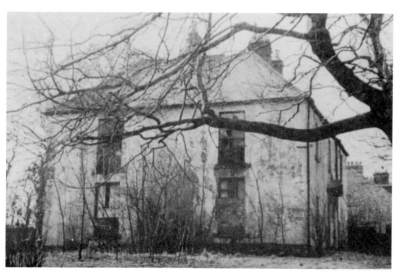

Earsdon White House.

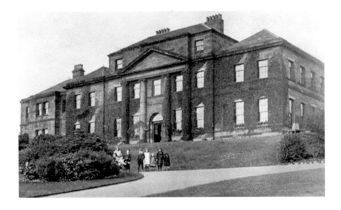

Elswick Hall.

Elswick Hall, Elswick

The first owners of the Elswick estate were the Jennisons, who bought land there in 1640. Sir Ralph Jennison greatly enlarged the estate, but it was sold by his great-grandson who preferred to live at Walworth Castle in County Durham. The estate was bought by the cloth merchant and mine owner John Hodgson whose grandson commissioned William and John Stokoe of Newcastle to rebuild the hall in 1803. In 1839 John Hodgson MP sold the estate to Richard Grainger. The house was later occupied by Christian Allhusen, a local manufacturer, but the estate was eventually put up for sale for building plots. It was, instead, bought by a number of wealthy Newcastle grandees who gave it to the city council as a public park. For some years the house was used to display sculpture by J. G. Lough. Unfortunately, due to rising costs, it was eventually abandoned by the council. It was demolished in 1977 and a swimming pool built on the site. Elswick Park survives.

Elvaston Hall, Ryton

Elvaston was the home of Sir Charles Parsons (1854–1931), inventor of the steam turbine. In 1896 it was described as a 'large modern stone mansion'.

Elswick House, Newcastle

Elswick House stood not far from Elswick Hall. From the 1880s until his death in 1918 it was the home of Sir William Haswell Stephenson, Lord Mayor of

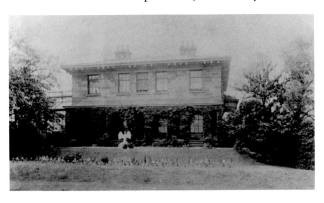

Elswick House.

Newcastle and philanthropist. Elswick House became a children's home in 1921 and then St Anne's Convent School for Girls. It was demolished in 1984. A Marie Curie Centre now stands on the site.

Ewart Park, Newtown

Ewart Park was redesigned by its owner, Colonel Horace St Paul, in the late eighteenth century. The colonel had accidentally killed a man in a duel and had been forced to flee the country, taking exile in Austria. After service in the Seven Years' War and being created a count of the Holy Roman Empire, he returned to Britain seeking, and gaining, a Royal Pardon and on retiring from military service, purchased the Ewart Park estate from his brother in 1775. John Collins had bought the Ewart estate earlier in the eighteenth century, leaving it to Robert Paul (b. 1697), husband of his sister Judith. When Robert died in 1762, Judith had the Paul name changed by Act of Parliament to St Paul. The house and estate passed to the Colonel's son and grandson and then to Mia St Paul, daughter of Horace III and goddaughter of Josephine Butler, the social reformer. On the death of Mia's son George Grey Butler in 1937, their son, Horace IV, was unable to maintain the property, which was occupied briefly by the military in the Second World War and has been derelict since then.

Tradition has it that Colonel St Paul received various unwanted architectural items from nearby Twizell Castle which was being built at the same time. These are said to have included a complete tower. A west wing was added in 1870. The entrance front has seven irregular bays to the main block dating from the nineteenth and four from the eighteenth century. The 1870 wing has thirteen bays and the north side a four-storey, round Gothick tower with a pointed-arched door on the ground floor. Ewart Park remains derelict.

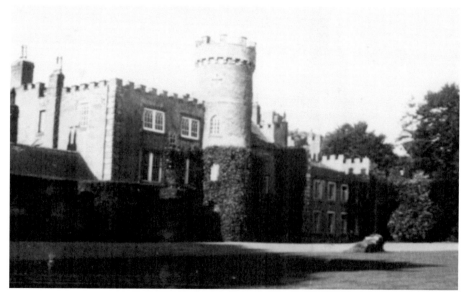

Ewart Park.

Felton Park, Felton

Felton passed from the Lisle family, whose ancient seat it was, to the Widdringtons in 1661 when Dorothy Lisle married Edward Widdrington. Dorothy Lisle was already a widow and was coheir of the Horsleys of Longhorsley. Her descendants became Horsley Widdringtons and her grandson Edward commissioned Felton Park in 1732, probably from Canston. The hall was subsequently rebuilt after a fire in 1747 and a wing was added in 1799. The original house was of seven bays by six and two and a half storeys. There were triple keystones over each window, but the facades were otherwise plain apart from a heavy cornice.

When Edward Horsley Widdrington died in 1762, his sole heiress was his daughter Elizabeth who married Thomas Riddell of Swinburne Castle. Their oldest son inherited Swinburne and their second, Edward, inherited Felton. The brothers died young without children and both estates passed to their younger brother, Ralph, who added an east wing to the house, dated 1799.

The Horsley Widdringtons remained at Felton until the twentieth century. The main house was demolished in 1952, although the 1799 wing survives. The grounds contain a greenhouse dating from 1830 using fish scale glass and wrought-iron glazing bars, which has been beautifully restored by the present owner.

Forest (Forrest) Hall, Forest Hall

Forest Hall incorporated the remains of a medieval pele tower. The adjacent five-bay block was probably built by Richard Wilson around 1730. A wing at the other end of the main front was added later. Forest Hall was often tenanted but the Wilsons returned to live there between around 1910 and 1956. It was demolished in 1962 but gave its name to the suburb built over its estate.

Gables, The Elswick

Also known as Hopedean House, The Gables was a 'Tudorbethan' house dating from the 1870s. It was built by the Quaker Richardson family whose fortune came

The Gables.

from leatherworking and who owned the Elswick Leather Works. The Richardsons sold The Gables in 1919 and the house became a maternity hospital which chose independence on the foundation of the NHS. The house next became a Salvation Army hostel which closed in its turn in 1974. The Gables was demolished in 1996.

Gibside, Derwent Valley

From 1200 the home of Marley family, Gibside passed to Roger Blakiston of Coxhoe in 1450. William and Jane Blakiston built a three-storey Jacobean house on their estate between 1603 and 1620. It became a Bowes property on the marriage of Sir William Bowes to Elizabeth Blakiston in 1693. From Sir William the house passed by descent to the Earls of Strathmore. The present hall was built by William on the site of an earlier house and has not been fully occupied since the end of the nineteenth century. At one stage plans were put forward to turn it into a hydropathic establishment, but it was gutted in the 1920s, used by land girls during the Second World War and partly demolished in the 1950s, although the late Queen Mother, daughter of the 14th Earl of Strathmore, remembered picnics at Gibside as a child in the early years of the twentieth century. The ruins stand at the heart of the designed landscape built by George Bowes who moved his main seat to Gibside from Streatlam, including the Palladian stables and Banqueting House, both by Garrett (1746), half-mile terrace, Paine and Garrett's *Column to British Liberty* and Paine's Chapel begun in 1769 but not completed internally until 1812. The estate is in the ownership of the National Trust and open to the public.

The mansion was enlarged in the mid-eighteenth century, in 1805 for the 10th Earl of Strathmore, probably by David Stephenson, and again in the later nineteenth by John Dobson. On the last of these occasions the second floor was removed. The south front is symmetrical with Tuscan columns (which once carried statues) on either side of the doorway. The hall rambles in a rather formless way along the ridge which edges Gibside to the north-east.

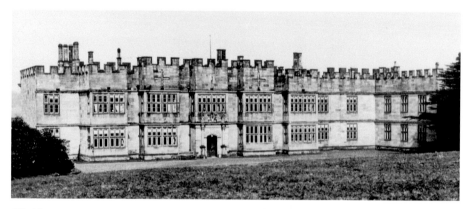

Gibside.

Gloster Hill, Amble

A late seventeenth-century manor house described as by, or in the style of, Trollope, Gloster Hill was the seat of the Lawson family. It was demolished in the

1930s but some fittings were taken to Dunstan Hall near Craster. Only two fine gateposts survive to mark the site.

Haggerston Castle, Haggerston

Richard Norman Shaw's water tower now stands sentinel over a caravan park. Of his huge mansion of the early 1890s, nothing but the tower survives.

The Haggerston family owned land at Haggerston in the twelfth century on which they built a defensive tower. The estate takes its name from a Norman by the name of de Hagarde. In 1314 Edward II issued a pardon to Philip and John de Hagardeston for their raiding over the Scottish border. In 1345 the tower at Hagarston Castle was crenelated. Thomas Haggerston, who raised a regiment for Charles I and defended his castle against Parliamentary forces, was made a baronet at the Restoration. A later Sir Thomas Haggerston, not satisfied with his ancient seat, constructed a new house of two storeys and seven bays.

The second Sir Thomas' grandson, Sir Carnaby, added a three-storey, three-bay block to each end of his father's house to create the south facade and demolished the tower house. Service rooms and service accommodation were also built. The remodelling was completed in 1805. Sir Carnaby bequeathed Haggerston to his grandson John Massey Stanley who was forced to sell the estate to cover his gambling debts. The house and 23,000-acre estate was bought in 1858 for £340,000 by John Naylor who had inherited a shipbuilding fortune from his uncle.

John Naylor's son, Christopher Naylor-Leyland (the Leyland being the name of his shipbuilding great-uncle), commissioned Richard Norman Shaw to hugely expand the house, which, like a number of Shaw's late buildings, showed great technical mastery of planning, considerable ingenuity and absolutely no charm. It was a white elephant on a stupendous scale even before it was finished. Shaw added three new wings behind the south front, enclosing a small courtyard, and included a great hall 84 feet by 40. The water tower was 153 feet high. A new stable block was added in the first decade of the twentieth century. An enthusiastic technophile, Christopher was also a director of the Marine Turbine Company which produced Turbinia, the world's first such ship.

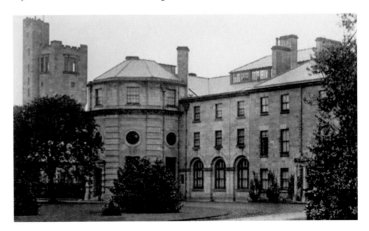

Haggerston Castle.

In 1911 Haggerston was ravaged by fire and much of the central block destroyed. Naylor-Leyland immediately set about repairs, commissioning the Edinburgh architect J. B. Dunn to redesign the south and west front, adding a clumsy colonnade and central portico as well as a porte-cochere. During the First World War, the house was a military hospital.

Leyland died in 1923 leaving the 154-room house to his son Christopher. Almost inevitably, the mansion was unsustainable and Christopher sold off parts of the estate, including Kidlandlee, living in a small part of the house. Finally, in 1931 the house and the remainder of the estate were sold to Mr R. Dagnall and the house pulled down. The sale of contents lasted five days and elements of the house can now be found scattered across the country houses of Northumberland. The gatepiers crowned with lions are now at Ellington Hall.

There are various survivors of estate and garden buildings including an icehouse, niched wall with statues from the Italian Garden, Priest's House (the Haggerstons were Roman Catholic) and animal house which once formed part of Christopher Naylor-Leyland's private zoo.

Heaton Hall, Heaton

Henry Babington bought Heaton in 1613. The later Heaton Hall was originally a classical building built in 1713, until Sir Matthew White Ridley gave it a skin-deep Gothic makeover, adding round turrets at either end of the entrance front. The architect was William Newton. White Ridley was descended from two of Newcastle's most significant early business dynasties; the Ridleys owned the Heaton estate, the Whites owned Blagdon. The White line ended with a daughter who married Matthew Ridley and it was their son who inherited both estates and transformed Heaton. In the second half of the nineteenth century Heaton belonged to the Potter family whose ancestor had started as a fitter for Armstrong and Company and ended as a director. Heaton Hall was demolished 1933. A circular temple from its grounds now stands at Blagdon, still the seat of the Ridleys.

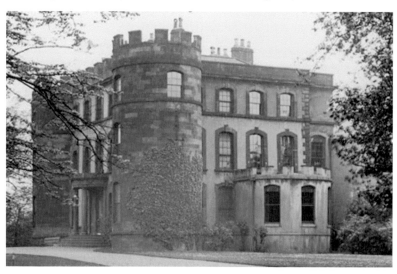

Heaton Hall.

Hepple Woodside, Hepple

Hepple Woodside was a mid-nineteenth-century mansion built by the Riddell family who purchased the property from the Duke of Portland. In the early part of the twentieth century the house was the property of Edward Newton. It was vaguely Gothic with multiple gables and mullioned windows. Hepple Woodside was demolished around 1970.

Hirst Castle, Ashington

Hirst Castle was demolished in 1908 as part of a road widening scheme. It was a fortified tower later used as a farmhouse and built in 1596, which once belonged to the Ogles and passed to the Erringtons in the eighteenth century. A façade described as 'Trollope style' had been added to one side in the early eighteenth century.

Hollymount Hall, Bedlington

Demolished in 1958 to make way for housing, Hollymount was a rather severe three-bay classical villa with a portico in antis. It was built in 1844 by John Birkenshaw, chief agent of the Bedlington Iron Works. Birkinshaw, an associate of Robert Stephenson, sold the house to his successor at the work, Michael Longridge, in around 1850.

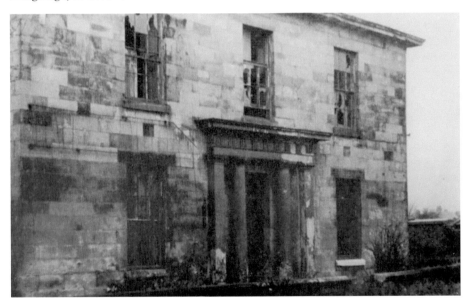

Hollymount Hall.

Jesmond Grove, Newcastle

The Recorder of Newcastle, James Losh, built and lived at Jesmond Grove from 1802 to 1833. John Dobson worked there in 1817 but the house was later Gothicised, probably around the mid-nineteenth century when the owners were Matthew and Thomas Alderson. The brewer W. B. Reid owned the house in the early twentieth

century when it was occupied by Henry Armstrong. From 1916 until it was demolished in 1927, Jesmond Grove was a boarding house for the Newcastle Church High School.

Jesmond Manor House, Newcastle

Also known as Jesmond House, Jesmond Manor House was rebuilt in 1720 by William Coulson on the site of the manor house granted to Nicholas Grenville by Henry I in the twelfth century. Sir Thomas Burdon bought the house from the Coulsons in 1805 and made significant alterations and in 1809 it was bought by John Anderson. Later residents included Sir James Knott, owner of the Prince shipping line, Alfred Cochrane and then the shipbuilder Sir Herbert Babington Rowell. It was later a nursing home and was demolished in 1929. In its final form the house had a central four-bay, two-storey block with dormer windows and lower two-storey, two-bay wings on each side. The manor house's iron gates were later re-erected as part of the Byker Wall housing development.

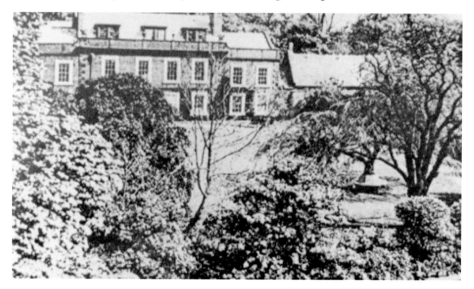

Jesmond Manor House.

Jesmond Park, Newcastle

Jesmond Park was a symmetrical classical villa with shallow bays and a surrounding veranda, to which a wing with a canted bay had been added. It was built in 1826 for the solicitor Armorer Donkin whose guests at Jesmond Park included William Cobbett and Leigh Hunt. On Donkin's death in 1851 the 30-acre estate was let to William George Armstrong. The house had a number of later residents from the Newcastle professional and business communities. It was demolished in 1899 and terraced housing built on the site.

Kenton Lodge, Newcastle

Kenton Lodge was built for John Graham Clarke, a local coal owner and the grandfather of Elizabeth Barrett Browning, in 1795. The Clarkes moved to

Kenton Hall in 1809 or 1810. From 1810 to 1836 Kenton was the home of John Brandling and it was then occupied for a short period by Sir John Walsham, a Poor Law Commissioner. Subsequent owners were mainly farmers.

The house was demolished in 1908 and replaced by a neo-Georgian house in Queen Anne style, built for the paint manufacturer Max Holzapfel. The later house survives and after serving for many years as part of Trinity School, now offers assisted living accommodation for the elderly. Holzapfel's firm, which makes marine anti-fouling paints, is still in existence nearby.

Kenton Manor (Younger's Farm), Newcastle

Kenton Manor was a small three-bay, three-storey house of around 1700. It was demolished around 1960. A small oriel window to one side was dated 1616 and the manor's appearance suggests it may have contained elements of a much older dwelling.

Kidlandlee, Kidland

Kidlandlee was said to be the highest mansion in England, standing in a remote location at almost 1,300 feet. It was built as a shooting box by C. J. Leyland of Haggerston, who bought the land from Hon. F. W. Lambton and sold it to the Lee family in 1925. As a director of the Parsons Marine Steam Turbine Company, Leyland was captain of *Turbinia* during her speed trials and when she made her dramatic appearance at Queen Victoria's Diamond Jubilee naval review at Spithead, he also gave his name to the common garden nightmare Leylandii (*Cupressocyparis Leylandii*). The gardens at Kidlandlee included a lake and a croquet lawn surrounded by rough grazing land. Kidlandlee was demolished by dynamiting in 1957; the stables survive. Much of the former estate has been planted with commercial forestry.

Killingworth House, Killingworth

According to local tradition, Killingworth House was designed in the 1760s by Lancelot Coxon. Alterations and additions were made by William Newton in the 1770s. Killingworth was the seat of Admiral Robert Roddam, once famous for storming a coastal battery in northern Spain in 1747, an action instrumental in bringing to an end the War of the Austrian Succession. The admiral died in 1808. John Jameson owned the house after 1876, and the McIntyres from 1900 to 1911.

Killingworth House.

Killingworth House was sold in 1924 when it was advertised as a 'Country Residence together with cottages, outbuildings, fields and gardens in all over 20 acres'.

The purchaser was the chemist Henry Eagle whose greatest commercial success was an antiseptic called Iglodine. Legend has it that a tunnel ran from Killingworth House to Seaton Delaval Hall, although this seems implausible given the distance between the two. Tunnels were said to have been found during the building of the housing development on the site of the house in the 1970s. Killingworth House was demolished in 1956.

Low Gosforth House, Gosforth

Low Gosforth House was originally part of the Brandling estate. In the early nineteenth century it was occupied by Robert William Brandling, younger brother of Revd Ralph Brandling of Gosforth House. When the Brandling properties were sold in 1852 Low Gosforth House and its estate of almost 300 acres was purchased by Joseph Laycock for £28,600. Laycock demolished the existing house and replaced it with a new one which burnt down in 1878 and was again rebuilt. Laycock's son Brigadier General Sir Joseph Frederick Laycock inherited the estate in 1881. By 1894 the house was the residence of James Woods' son John Antony Woods of Benton Hall, who later moved to Swarland Park. Subsequent owners included Brodie Cochrane and Sir Alfred Bell. The estate was later used for residential development and the house was demolished in the early 1970s. The stables and outbuildings were converted for use as housing. Low Gosforth House was also known as Low Gosforth Court.

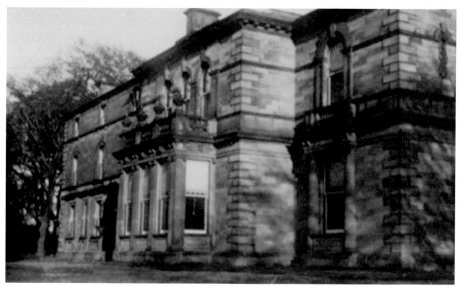

Low Gosforth House.

Low Lynn, Kyloe

The ruins of Low Lynn, which stand on the site of a deserted medieval village, are of a mid-eighteenth-century house which was built for John Gregson (d. 1774).

The house had five bays and was extended in the nineteenth century. The Gregsons, later Knight-Gregsons, owned the estate until after the Second World War. In 1938, Low Lynn was requisitioned by the Royal Air Force Coastal Command, and was later used to house PoW German officers. The house was never again occupied and its condition gradually deteriorated; only a shell remains.

Mansion House, Newcastle

Newcastle's present Mansion House is late Victorian, built in 1886. It became the official residence of the Lord Mayor after it was given to the City Council in 1953. Its predecessor was a classical building dating from 1691, when it cost £6,000 to build. It had its own wharf in an area of the city which became increasingly unsuitable as industrialisation progressed. It was sold in 1836 and after a period as a timber warehouse, it burnt down in 1895.

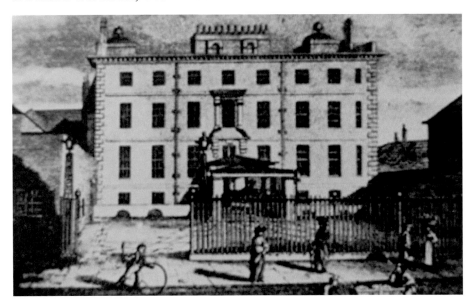

Mansion House.

Milfield Hill, Milfield

The Greys lived at Milfield from 1754 until the second half of the twentieth century. The house appears to have had a complex building history, the main three-bay façade with canted bays possibly dating from 1793. Above the door were carved the Grey family motto and badge of a scaling ladder. Milfield served as accommodation for RAF personnel during the Second World War and was demolished in 1967.

Monkwearmouth Hall, Monkwearmouth

Until it was destroyed by fire in 1790, Monkwearmouth Hall was the seat of the Williamson family. Previous owners of the hall, which had been built after the Dissolution from the stones of Monkwearmouth Monastery, had included the Whiteheads and Widdringtons. After the fire the Williamsons moved to Whitburn

Hall. Sir William Williamson married the daughter of John Hedworth of Harraton Hall but sold his share of the estate to Ralph Lambton.

Mounces, Bellingham
Mounces was a shooting box belonging to Sir John Swinburne of Capheaton and stood amongst 17,000 acres. The house was later used to accommodate forestry workers and now lies submerged by Kielder water reservoir.

Newbiggin Hall, Westerhope
An early nineteenth-century house which replaced the earlier house of the Hudson family, Newbiggin Hall (or House) was demolished in the 1950s. The house had a number of owners including, in 1828, John, son of Matthew Bell MP, Lt Col Charles Reed, the steel manufacturer John Watson Spencer and, after 1909, Gerald France MP whose widow lived there until her death in 1954. Newbiggin was replaced by a public house which has now also been pulled down.

Newburn (Old) Hall, Newburn
The core of Newburn Hall was a fifteenth-century pele tower which was enlarged when a house was added in around 1600. The pele had a vaulted basement and a prominent projecting garderobe. Mrs Lydia Bell was living at Newburn in 1765. In 1891 the east wing burnt down. The remains of the house were incorporated into Spencer's steelworks and demolished when the site was cleared in the 1920s. A fireplace from Newburn was moved to Washington Old Hall.

Newburn Manor, Newburn
A small manor house of around 1600, of three bays with mullioned and transomed windows, Newburn Manor was demolished in 1909. Two of the fireplaces from Newburn are said to be at Alnwick Castle. From the fourteenth century the manor house at Newburn was a property of the Percy family.

North Elswick Hall, Newcastle
North Elswick Hall was probably built in the 1830s. Between the 1850s and 1919 it was the home of the Milvain family. The hall was then sold to the Roman

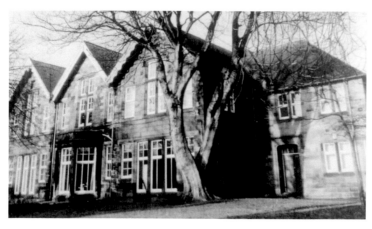

North Elswick Hall.

Catholic Diocese of Newcastle for use as a school. The hall was demolished around 2005.

North Seaton Hall, Seaton

Of three storeys, five bays and stone built, North Seaton Hall was constructed around 1710. The ubiquitous Dobson may have carried out alterations in around 1813. The builder was a Mr Watson and the Watson family owned the hall until the late nineteenth century. In 1877 North Seaton Hall was occupied by Robert Watson and ten years later by the industrialist Sir Isaac Lothian Bell. Following a period of decay, it was demolished around 1960.

Oakwood Hall, Wylam

Oakwood was built in three phases in the early and late eighteenth and the later nineteenth centuries. Once a seat of the Blackett family, in the late nineteenth century Oakwood was the home of the industrialist Norman Charles Cookson. Oakwood was on the market in 2019 in a derelict state.

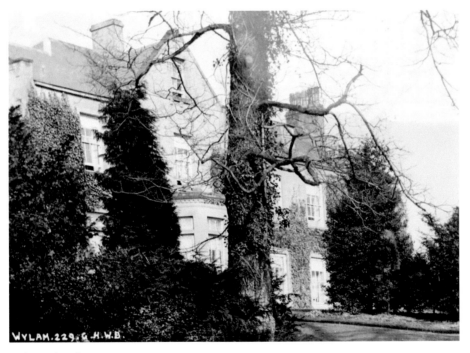

Oakwood Hall.

Otterburn Dene House, Otterburn

A Georgian house with Victorian additions, the area where the house stood is now part of an army camp, much of the estate having been sold off in the 1920s. In 1855 R. S. Coward lived at Otterburn Dene, in 1858 Nicholas Wright and 1887 Richard Burdon-Sanderson. In the 1920s Major H. C. H. Hudson lived in the house which later became a hotel. Otterburn Dene was demolished around 1970.

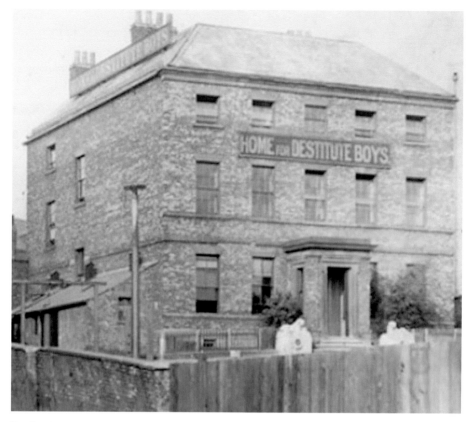

Pandon House.

Pandon House, Newcastle

Pandon House was a rather severe three-storey, five-bay house with exceptionally plain facades which stood on a steep slope down to the Tyne. After a period as a home for destitute boys, in 1925 the building became a printer's workshop. Pandon House was demolished around 1930.

Pawston Hall, Pawston

Like so many Northumberland houses, Pawston was built around a pele tower and was the seat of the Selby family. The hall was largely rebuilt in the eighteenth century and enlarged around 1870 in Gothic style. Long a ruin, the remains of the hall have been demolished. Henry Collingwood Selby bought the house from relatives in 1789. He had no grandchildren, but after the death of his only daughter, other members of the Selby family occupied the hall until 1921 when it was sold.

Prudhoe Hall, Prudhoe

Prudhoe Hall was built in 1878 for the mine owner Matthew Liddell, son of Cuthbert Liddell of Benwell Hall. Staunchly Roman Catholic, the Liddells

maintained a chapel and priest at the hall. Matthew Liddell died in 1881 and shortly afterwards his widow built a Roman Catholic church in the grounds of the house, replacing the chapel in the hall which had become too small for the congregation. The property was inherited by a nephew, John Liddell, one of whose sons won the Victoria Cross in 1915, but sold in 1904 to Col Swan, managing director of Swan Hunter. The Liddells paid for the church to be dismantled and moved to a new site away from the hall and the bodies of the deceased Liddells were moved with the church. Colonel Swan died in 1908 and in 1913 his descendants sold the hall and estate to the Poor Law Guardians. It then became Prudhoe Hall Colony, a home for the mentally handicapped. After the First World War, the hospital continued to develop and Prudhoe Hall became the hospital's administration block. The hospital has since closed and the hall is in poor condition.

Red House, Wallsend

The five-bay, three-storey Red House was built around 1770 for the Waters family who occupied it until 1799 when it was sold to John Walker. Later owners included Francis Peacock and John Allen. In the 1880s Red House was a children's home. It was demolished in 1897.

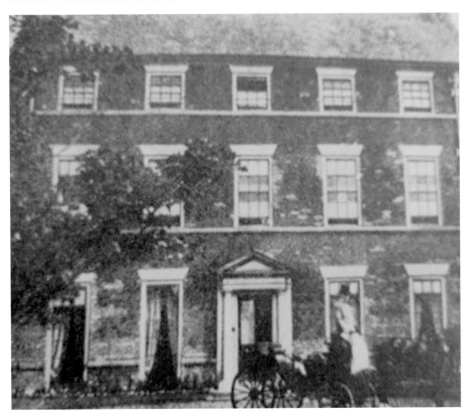

Red House.

St Wilfrid's, Hexham

Richard Gibson, a Hexham lawyer, built St Wilfrid's in the 1860s. It was a vaguely Gothic house with irregular facades and prominent Dutch gables. After the death of Gibson's son Jasper in 1917, the Hexham War Memorial Committee bought the property and it became a cottage hospital which opened in 1921. St Wilfrid's was demolished in 1995 after the closure of the hospital and the land used for housing.

Seaton Lodge, Seaton Sluice

According to tradition, the lodge was originally a Norman manor house in which the hiding place of King John was shown to curious visitors. Seaton Sluice was developed as a port by Sir Ralph Delaval in order to promote exports of coal, salt and stone from his estates. Delaval died in 1691 and his son Sir John, who boasted that the lodge was 'the finest thatched house in the Kingdom', sold most of his property to Admiral George Delaval, builder of Seaton Delaval in 1719. Sir Ralph had lived in the manor house on the site of Seaton Delaval before moving to Seaton Lodge and is known to have entertained Samuel Pepys at Seaton Lodge in 1682. For many years Seaton Lodge was the residence of the agent to the Delaval estates. Later occupants of the lodge included Thomas Harwood, master mariner, and John Jobling, a coal owner. The Misses Jobling were known for their philanthropy and for being the 'two best swimmers in the North of England'. Seaton Lodge was demolished in the 1970s.

Sparrow Hall, Cullercoats

Built by Thomas and Elizabeth Dove of the mine-owning Dove family in 1682, Sparrow Hall took its name from the dove carved, together with the initials of the builders, on one of the gables. Thomas' grandfather had established a burial ground for Quakers and members of non-established churches in the rapidly developing coal port of Cullercoats. The younger Thomas Dove sold the house to his delightfully named relative Zephaniah Haddock, a local cordwainer, in 1706. The house was later divided between Haddock's daughters. The hall had a central three-storey porch with a single bay of mullioned windows and two storeys on either side. Sparrow Hall was demolished in 1979.

Stotes Hall, Jesmond

The original hall was rebuilt in 1607, the date commemorated by a plaque above the door bearing that date and the arms of the Merchant Adventurers of Newcastle. Oliver Cromwell is traditionally believed to have stayed there in 1650. In 1658 the hall was purchased from Sir Francis Anderson and renamed by Sir Richard Stote. In 1756 Sir Robert Bewick and John Craster were the purchasers and for a short period Stotes Hall was a school run by the eminent mathematician Dr Charles Hutton. John Scott, one of Hutton's pupils, later became Lord Chancellor of England and was raised to the peerage as Lord Eldon.

The hall attained its final form when occupied by the Shields family in the early nineteenth century and had numerous later owners before it became the residence of Sir Alfred Appleby, the Newcastle coroner. Appleby sold it to Doris Cowper

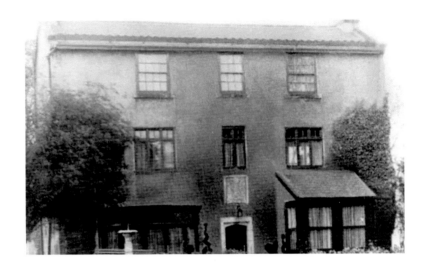

Stotes Hall.

who restored it. The hall was damaged during the Second World War whilst in use as an Air Raid Precautions depot and after a period of use by St John Ambulance Brigade, was demolished in the 1950s.

Swansfield House, Alnwick

The architect of Swansfield was Dobson, who designed it in 1823 for Henry Collingwood Selby. The house was demolished around 1975. A column celebrating an 1814 peace treaty survives.

Swarland Park, Swarland

Anciently the property of the Hesilrige family, after the death of the last baronet, Richard Grieve, an Alnwick solicitor, bought the Swarland estate in 1753. Richard's son Davidson Grieve inherited it in 1765 and began the process of rebuilding the mansion, almost certainly to designs by John Carr. However, Grieve's trustees sold the house in 1793 to Alexander Davison, Nelson's prize agent, who, in tribute to the source of his wealth, planted trees in the park to represent the positions of the ships at the Battle of the Nile.

The Davisons remained at Swarland until the mid-nineteenth century when the estate was sold. It had a number of short-term owners before it was purchased by the Woods family of Benton Hall who lived there until 1922 when they sold it to a colliery company. In 1934 the Fountains Abbey Settlers Society bought the estate and built housing on it. The hall was demolished in 1934 but the gate lodges survive.

Davidson's Nelson Monument also survives, bearing the inscription

England expects every man to do his duty. Victory, 21 October, 1805. Not to commemorate the public virtues and heroic achievements of Nelson which is the duty of England, but to the memory of private friendship, this memorial is dedicated by Alexander Davison.

Sadly, Davison was imprisoned for fraud the year after erecting his memorial. The tree plantings in the park also survive as memories of Davison's tribute to his friend.

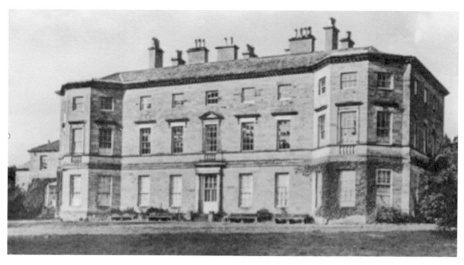

Swinburne Castle.

Swinburne Castle, Chollerton

There was a fortified house at Swinburne in 1346, when a licence to crenelate his '*mansum suuin de West Swvnborn*' was granted to Roger Wyddrington, but the house was described as 'in decay' by the middle of the sixteenth century. Roger Widdrington had acquired the property from Gilbert de Colwell in 1343. Swinburne was bought from the 3rd Lord Widdrington by his cousin Thomas Riddell of Fenham in 1678. Thomas' great-grandson, also Thomas, demolished most of the old castle at Swinburne and built the three-storey, five-bay block which formed the central portion of the later house. The earlier (sixteenth-century) manor house (which partially survives) became the west wing of the new mansion and was converted into service rooms. He added the three-bay canted wings at either end of the facade in 1771, possibly to the designs of William Newton. The castle was demolished in 1964, by which time it was in a very poor state. It had not been lived in by the family since 1937, although it had been occupied by Sacred Heart nuns during the Second World War. The Riddells retained the estate.

A smaller house, designed by the Newcastle architect Richard Elphick for Major and Mrs Richard Murphy, was completed in 2000. Mrs Murphy is one of the five daughters of the late John Cuthbert Widdrington Riddell, thus maintaining a family link with the castle which began in the mid-fourteenth century. The new house incorporates the sixteenth-century west wing of the earlier house and its orangery.

The eighteenth-century stables and Roman Catholic chapel of 1841 built by Thomas Riddell also survive, as does the entrance lodge.

Tillmouth Park, Twizell

Looking more like a factory than a country house, Tillmouth Park was built by the Blake family who also built Twizell Castle and Fowberry Tower. The Blakes acquired Tillmouth on the marriage of Elizabeth Carr to Sir Francis Blake (1638–1718).

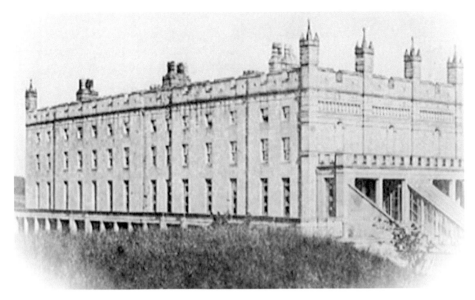

Tillmouth Park.

On Blake's death the estate passed to his grandson Sir Francis Blake 1st Bt. The house was probably rebuilt around 1810 by Sir Francis Blake and in its final form had a main front of fourteen bays, almost unrelieved by any form of decoration. The ends were of three wide bays, blind on the upper levels, the bays separated by pilasters crowned by strange turrets.

This house, which was never completed, was demolished in 1880 and the grandson of Sir Francis built the present house, now a hotel, nearby to the designs of Charles Barry Junior. The new Tillmouth contains fireplaces from the earlier house.

Troughend Hall, Otterburn

The Reeds were a force to be reckoned with in Redesdale for 800 years and the mid-eighteenth-century house built by Elrington Reed in 1758, which was demolished in the mid-1950s, replaced an earlier pele as their seat. Parcy Reed of Troughend was a noted reiver, appointed Keeper of Redesdale, who was treacherously murdered by the Halls of Otterburn after being invited hunting by them. His ghost is said still to haunt the Batinghope Burn crying out for justice. A famous border ballad describes his demise. In 1886 after the departure of the Reeds, Troughend was occupied by Messrs William and Henry Thompson.

Twizell Castle, Twizell

Originally the seat of the Selby family, the Twizell estate was sold to Sir Francis Blake in 1685. In the 1760s and 1770s a later Sir Francis replaced the old house with a new 'pasteboard' Gothic castle, the building of which was continued by his son, who succeeded in 1780. The result was extraordinary: a five-storey, C-shaped block with a massive tower at each of the four outer corners. There was a basement with four storeys above, three with rows of

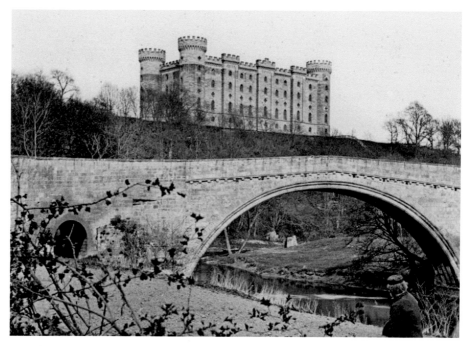

Twizell Castle.

pointed windows, the second with a series of quatrefoil windows. The longest face overlooked the river and had nine bays with one of the towers at each end. Three of the bays projected forwards slightly, going some way to breaking up the enormous wall area. Twizell Castle, which was never entirely finished, was, sadly, demolished in 1880, some of the stone being used to build the second Tilmouth Park. The remains of the original medieval castle, now freed of the mansion that surrounded them, remain. The Blake family continue to live at Twizell in the Dower House which was remodelled in 1976 for Sir Francis Blake by Felix Kelly.

Twizell House, Warenford
Twizell House was probably built before George Selby purchased the 643-acre estate in 1790. The porch was added in 1812 by George Wyatt for Selby's son Prideaux John Selby, a noted naturalist and author of *Illustrations of British Ornithology*, and *History of British Trees*. PJ Selby's walled garden survives. The Selbys left Twizell in 1892. Twizell House was demolished in 1969.

Wellburn, Newcastle
Frank Rich designed Wellburn for the paint manufacturer William Henry Holmes who bought the land in 1879. William Henry's son John Henry established an electrical engineering business and Wellburn was the first private house in Newcastle to be lit by electricity. Wellburn was demolished in 1931 and semi-detached housing was built on the site.

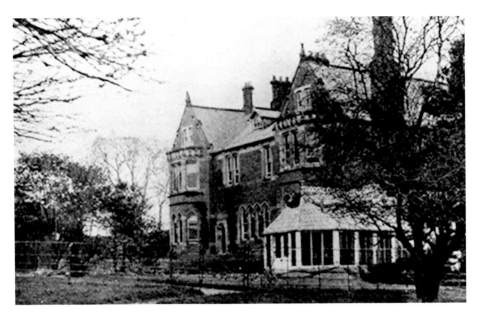

West Acres (Benwell West Park).

West Acres (Benwell West Park), Benwell

Benwell West Park was a Victorian Gothic house with a large conservatory. In 1888 Sir Benjamin Browne, solicitor and mayor of Newcastle, bought it from Percy Westmacott and changed its name to West Acres. Signs of mining subsidence soon became apparent. Sir Benjamin died in 1917 and on the death of his widow in 1929 West Benwell was sold to a builder who demolished the house and developed the 7 acres of gardens as a housing estate. Only a gardener's cottage survives.

West Jesmond House, Newcastle

A mid-nineteenth-century house in a rather fussy style with lots of gables, prominent chimneys and a large conservatory, West Jesmond House was the home of the prominent Newcastle brewer T. W. Lovibond. In 1934 the house became a private hospital for women called Lynton House. The building was demolished around 1970 and a new private hospital built on the site.

Westmoreland Place, Newcastle

In 1736 Westmoreland Place was described as having 'Magnificence and Grandure of Antiquity in it's [*sic*] looks' and was then lived in by Sir Robert Shaftoe and later Mr Charles Clark. The house had been built in the mid-fourteenth century by the Baron of Bywell and Bolbeck and by the end of the century, it had acquired the name Westmoreland House after Ralph Nevil, Earl of Westmoreland. In 1569 James Bertram held the property from the Nevils and Westmoreland House survived into the nineteenth century and still stood in 1827, but its date of demolition is unknown.

Whitley Hall, Whitley Bay

The Hudsons were long-established mine owners when Henry Hudson built his new house in around 1760, replacing an earlier house which had belonged to the Dove family to whom the Hudsons were related. To celebrate his marriage to his cousin, Hudson added single-storey wings with canted bays in 1776. He left the estate to his brother-in-law Henry Ellison who sold it to the Duke of Northumberland. The hall was later occupied by Joseph Harrison Friar. The council refused the gift of the hall and park and the hall was demolished 1899. The site is now occupied by a police station. The main block of the hall had an unusual appearance with two small triangular pediments, each over two and a half of the five bays. Until St Paul's Church was built in 1864, rooms at Whitley Hall were used for church services.

Whitley Park, Whitley Bay

Whitley Park was built by the cattle breeder Edward Hall around 1790 as a strangely asymmetrical stuccoed house with a four-storey, two-bay tower. The land had previously belonged to the Dove family. Hall was famous for being

Whitley Park.

the breeder of 'The Large Ox', immortalised by Thomas Bewick. The family had been long established in Whitley, their fortune coming from property, farming and brewing.

On Hall's death in 1792 the estate was bought by John Haigh, who extended the hall but went bankrupt and emigrated to the USA. In 1820 Thomas Wright bought it, occupying it until 1840 and enlarging it further. No subsequent owner seems to have occupied the property for very long; residents included John Hinde who bought it in 1844, then, amongst others, Major Streatfield and Edward Spoor. A substantial castellated addition was made by T. W. Bulman in the 1860s. Bulman died in 1879 and the estate was sold again, to L. W. Adamson and Thomas Hoyle.

Whitley Hall became a hotel in 1897 when most of the estate was sold. In 1922 the hall became council offices and it was demolished in 1939. A library was built on the site but this too has been demolished.

Wingrove House, Fenham

Early owners of Fenham included the Knights Templar and the Riddell and Orde families. Wingrove House was built in the 1840s for Lawrence Hewison, a corn factor, and demolished around 1903 when its then owner, John Wigham Richardson, retired to Stocksfield.

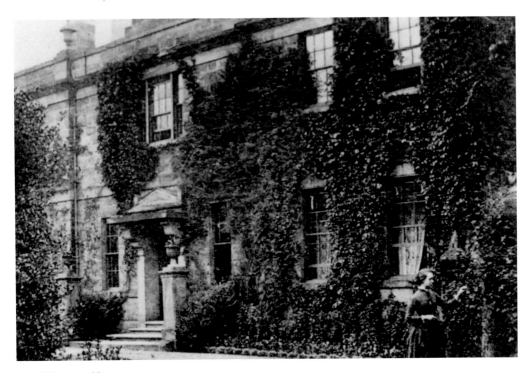

Wingrove House.

Woodhall, Holystone
Woodhall was an eighteenth-century house demolished in the late 1960s.

Woodhorn Manor, Woodhorn
Demolished in the 1970s, Woodhorn Manor was an early nineteenth-century house. In the 1870s it was home to Sir Jacob Wilson, Director of the Royal Agricultural Society.

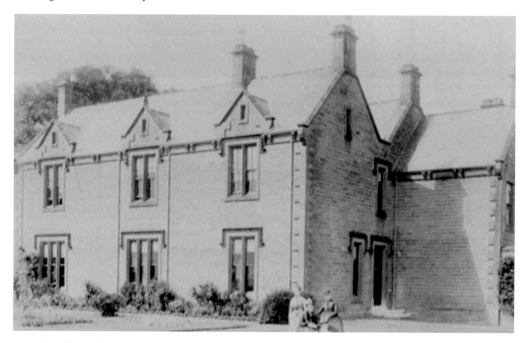

Woodhorn Manor.

Other Houses

County Durham

Beaurepaire, Durham Thirteenth-century Bishops' Palace. Derelict by 1684. Ruins survive.

Binchester Hall, Binchester Seat of the Wren family from 1570, then Bowes family. Demolished 1833.

Blakiston Hall, Norton. Seat of the Blakistons for 300 years. Sold around 1800, demolished late nineteenth century.

Bradley Hall, Wolsingham Medieval manor house, ruinous by 1794. Substantial ruins survive.

Carr Hill House, Gateshead Late eighteenth century. Later a lunatic asylum. Demolished 1921.

Dalden (Dawden) Tower, Seaham Pele replaced by early seventeenth-century manor. Derelict by the end of the eighteenth century. Ruins survive.

Deckham's Hall, Gateshead Named for Thomas Deckham. Possibly seventeenth century, rebuilt early nineteenth century. Demolished 1930.

Deneholme, Horden Possibly eighteenth/nineteenth century. Demolished after 1922.

East Hall, Great Lumley Ancient seat of the Lumleys. Scene of murder of Ligulf by henchmen of Bishop of Durham. Long demolished.

Elvaston Hall, Ryton Nineteenth century. Home of Sir Charles Parsons, inventor of the steam turbine.

Egglestone Abbey, Barnard Castle Converted from an abbey post reformation. Ruined by end of eighteenth century.

Ferndene, Gateshead Jacobethan, built 1850s for Robert Newall. Demolished 1920s.

Fishburn Hall, Sedgefield Early medieval manor. Boys' school in the nineteenth century. Demolished in 1953.

Grindon Manor House, Grindon Probably late nineteenth century, for Vaux family. Demolished *c.* 1960.

Harraton Hall, Chester-le-Street Ancient manor, various dates, parts incorporated into Lambton Castle.

Hollinside Hall, Whickham Late thirteenth-century/early fourteenth-century manor. Long derelict, only fragments remain.

Hunter's Hall, Sunderland Built 1670s. Frequently visited by John Wesley. Demolished early twentieth century.

Hylton Castle, Sunderland Late fourteenth-century tower house, extended seventeenth century, eighteenth century, nineteenth century. Reduced, tower remains.

Long Newton Hall, Stockton Seat of Vanes, later Marquesses of Londonderry. Demolished by 1823.

Ludworth Tower, Shadforth Early medieval fortified house. Only fragments remain.

Mid Hall, Widdrington Early seventeenth-century seat of the Salkelds. Demolished early nineteenth century.

Newton Cap Hall, Bishop Auckland Earlier and mid-eighteenth-century halls, both demolished mid-nineteenth century.

North Hylton Grange, Sunderland Brick villa, late eighteenth or early nineteenth century. Demolished 1980s.

Old Dockendale Hall, Blaydon Seat of the Silvertops. Empty by 1840, demolished 1904.

Old Durham Hall, Shincliffe Late sixteenth-century mansion. Demolished eighteenth century.

Outside Hall (Harraton Hall) Chester le Street Part of estate of Earls of Durham. Demolished 1730.

Rainton Hall, West Rainton Built by Sir John Duck in 1688. Derelict by 1880, later demolished.

Ravenshill, Gateshead Mid-nineteenth century with pre-Raphaelite details. Later a social club. Demolished late twentieth century.

Simonside Hall, South Shields Built or rebuilt 1784, extended nineteenth century. Demolished 1973 and earlier.

Snotterton Hall, Staindrop fourteenth/fifteenth-century house. Seat of Bainbridges in the fifteenth century to 1607. Demolished 1831.

Stanley Hall, Tanfield First mentioned 1394. Demolished 1930s.

Thorney Close Hall, Sunderland Seat of the Whites. Demolished early twentieth century.

Thornhill House, (Plenty or Plentiful Hall) Sunderland Built *c.* 1770. Extended nineteenth century. Demolished 1906. A lodge survives.

Tynemouth Lodge, Tynemouth Built 1790 by Walter Linskell – brick with canted bay. Demolished 1858.

Wemmergill Hall, Wemmergill Nineteenth-century shooting box at heart of 17,000-acre estate, demolished 1980s.

White House, Heworth Various periods from seventeenth century. Demolished 1960s.

Whitworth Hall, Spennymoor Seat of the Shaftos. Built 1820, burnt down 1876 and replaced.

Willington House (High Willington House) Willington. Brick built *c.* 1800. Demolished mid-twentieth century.

Windlestone Hall, Rushyford Seat of Edens from 1560, rebuilt by Bonomi 1835. Derelict. Proposals for redevelopment are being considered.

Winlaton Hall (Crowley's Castle), Winlaton Early medieval and later. Demolished 1928.

Woolsington Hall, Woolsington Various periods including work by Dobson. Derelict after a fire.

Northumberland

Beacon Grange, Hexham Probably built by Gibson family. Demolished 1937.

Belsay Castle, Belsay Seat of the Middletons from the thirteenth century. Pele tower with Jacobean house. Ruins now a garden feature, Belsay Hall.

Birdhope Craig Hall Rochester shooting box. Built 1782, rebuilt. Demolished 1963 after a fire.

Clubdon Hall, Lamesley Seat of the Claverings. Connections to Lewis Carroll and Catherine Cookson. Demolished.

Collingwood House, Whittingham Early nineteenth-century house, demolished late nineteenth century.

Grange, The, Wallsend Eighteenth-century brick house with five bays. Demolished 1913.

Grey Court, Riding Mill Probably nineteenth century. Burnt down 1940 and replaced with a smaller house.

Jesmond Dene House, Newcastle Built by Lord Armstrong, work by Norman Shaw. Demolished. Ruined Banqueting House (Shaw) survives.

Kirkharle Hall, Kirkharle Seat of Lorraines from the fourteenth century. Fragments remain as a farmhouse. Birthplace of Capability Brown.

Mitford Manor House, Mitford Seat of Mitfords from pre-Conquest. Late sixth century. Replaced by Georgian Mansion. Ruins survive.

Orde House, Morpeth Built 1715 for Orde family. Demolished 1967.

Paradise House, Scotswood Early eighteenth century. Demolished 1958.

Point Pleasant House, Wallsend Eighteenth century with canted bay. One wing survived until 2009.

Ray House, Kirkwhelpington Seat of Parsons, inventor of steam turbine. Demolished 1945.

Riddlehamhope Hall Hexham Nineteenth-century shooting box. Possibly including a bastle. Demolished from 1950.

Scotswood House, Newcastle Early nineteenth century. Demolished around 1970.

Scotswood Tower, Newcastle Nineteenth century, possibly with medieval tower. Demolished 1970s.

Sidwood, Greenhaugh Eighteenth-century farmhouse and nineteenth-century country house. Burnt down and demolished.

Weldon Hall, Brinkburn Seat of the Lisle family from at least the seventeenth century. Demolished 1890s.

Whickhope Lodge, Falstone Shooting box of Duke of Northumberland. Now under Kielder Water.

Widdrington Castle, Widdrington Mid-fourteenth century and later. Rebuilt as country house several times. Demolished 1862.

Willimoteswick Manor, Bardon Mill Thirteenth-century fortified manor. Parts including gatehouse survive as a farm. Traditional birthplace of Archbishop Ridley.

Bibliography

Books

Allsopp, Bruce and Clark Ursula, *Historic Architecture of Northumberland* (Newcastle Upon Tyne: Oriel Press, 1969)

Bourn, William, *History of the Parish of Ryton, including the Parishes of Winlanton, Stella, and Greenside* (Carlisle: G. & T. Coward Printers, 1896, reprinted Cedric Chivers Ltd, Bristol, 1999)

Brack, Sandra, *Gateshead's Grand Houses* (Newcastle Upon Tyne: Summerhill Books, 2012)

Brack, Sandra, Bob Dixon, Margaret Hall, Helen Ward, *Gateshead's Grand Houses Revisited* (Newcastle Upon Tyne: Summerhill Books, 2016)

Brewster, John, *History of Stockton on Tees* (Stockton on Tees: Thomas Jennett, 1829, reprinted Patrick and Shotton, Stockton on Tees, 1971)

Burke's Peerage, Baronetage and Knightage 107th Edn (Wilmington Delaware: Burke's Peerage and Gentry LLC, 2003)

Campbell, Colen, *Vitruvius Britannicus* (Mineola, New York: Dover Publications Inc.)

Chapman, Vera, *Darlington Remembered (Images of England)* (Gloucestershire: Tempus, 2005)

Davidson, Jim, *Northumberland's Lost Houses: A Picture Postcard History* (Hexham: Wagtail Press, 2008)

Dodds, Glen Lyndon, *Historic Sites of County Durham* (Albion Press, 1996)

Dodds James, *The History of the Urban District of Spennymoor* (Spennymoor, published by the author, 1897)

Faulkner, Thomas and Lowery, Phoebe, *Lost Houses of Northumberland and Newcastle* (Jill Raines, 1996)

Faulkner, Thomas and Andrew Greg, *John Dobson: architect of the North East* (Tyne Bridge Publishing, 2001)

Graham, Frank, *The Old Halls, Houses and Inns of Northumberland* (Newcastle Upon Tyne: Frank Graham, 1977)

Green, Martin, *The Delavals: A Family History* (Powdene Publicity, limited 3rd edn, 2014)

Heald, Henrietta, *William Armstrong, Magician of the North* (McNidder and Grace, 2010)

Maria Hoy, *Bygone Fenham*, (Newcastle Upon Tyne: Newcastle Upon Tyne City Libraries and Arts, 1988)

Hugill, Robert, *Castles of Durham* (Frank Graham, 1979)

William Hutchinson, *The History and Antiquities of the County Palatine of Durham* (Durham, 1787)

Jamieson, James, *Durham at the Opening of the Twentieth Century* (Brighton: WT Pike and Company, 1906)

Lloyd, Chris, *Darlington in 50 Buildings* (Stroud: Amberley Publishing, 2017)

Longstaffe, W. Hylton Dyer, *The History and Antiquities of the Parish of Darlington* (Darlington: Darlington and Stockton Times, 1854)

McNee Tom and David Angus, *Seaham Harbour: The First 100 Years 1828-1928* (1985)

Meadows, Peter and Edward Waterson, *Lost Houses of County Durham* (York: Jill Raines, 1993)

Menzies, Paul, *Billingham* (The History Press, 2008)

Middleton, Arthur E., *An Account of Belsay Castle* (Newcastle: Mawson, Swan and Morgan, 1910, reprinted 1990, The Spreddon Press, Stocksfield)

Alan Morgan, *Jesmond: From Mines to Mansions* (Newcastle: Tyne Bridge Publishing, 2010)

Morris, Richard, *Yorkshire* (London: Weidenfeld and Nicolson, 2018)

Neasham, G., *Views of Mansions and Places of Interest in the Lanchester and Derwent Valleys* (1884)

Palmer, Liz *Bygone Kenton* (Newcastle Upon Tyne: Newcastle Upon Tyne City Libraries and Arts, 1993)

Parsons, William, *History, Directory and Gazeteer of the Counties of Durham and Northumberland* (Leeds: W. White and Co., 1828)

Peacock, Jonathan, *Streatlam Castle* (Bowes Museum, 2017)

Perry, P. and D. Dodds, *Curiosities of County Durham* (Stroud: Amberley Publishing, 1996)

Pevsner, Nikolaus and Ian Richmond (Revised by John Grundy, Grace McCombie, Peter Ryder and Humphrey Welfare) *The Buildings of England: Northumberland* (Newhaven and London: Yale, 2002)

Pevsner, Nikolaus and Williamson, Elizabeth, *The Buildings of England: County Durham* (Newhaven and London: Yale, 2002)

Pevsner, H., *Yorkshire: the North Riding (The Buildings of England)* (Newhaven and London: Yale University Press, 2002)

Raymond, Hugh, *The Mitford Family* (Newcastle: Zymurgy Publishing, 2016)

Ritson Darren, W., *Haunted Northumberland* (History Press, 2011)

Robinson, John Martin, *Felling the Ancient Oaks: How England Lost its Great Country Estates* (Aurum Press, 2011)

Salter, M., *The Castles and Tower Houses of Northumberland* (Malvern: Folly Publications, 1997)

Salter, M., *The Castles and Tower Houses of County Durham* (Malvern: Folly Publications, 2002)

Simpson, David, *The Durham Villages* (*The Northern Echo*, undated)

Simpson, David, *Chester le Street and Washington* (*The Northern Echo*, undated

Smith, Douglas W. *Herrington and its Folk* (Middle Herrington, 1987)

Sproule, Anna, *Lost Houses of Britain* (Newton Abbott: David and Charles, 1982)

Strong, Roy, *The Destruction of the Country House* (London: Thames and Hudson, 1974)

Surtees, Henry Conyers and Henry Reginald Leighton, *Records of the Family of Surtees: Its Descents and Alliances* (Newcastle-upon-Tyne, 1925)

Thorne, Trevor, *The Grand Mansions of Wearside* (Dalmahoy Books, 2020)

Tomlinson, William Weaver, *Historical Notes on Cullercoats Whitley and Monkseaton* (London, 1893; New Edition Newcastle Upon Tyne: Frank Graham, 1980)

Clarence R. Walton, *Romantic Ravensworth* (Newcastle Upon Tyne: The Summerhill Press, 1950)

Whittaker, Neville and Ursula Clark, *Historic Architecture of County Durham* (Newcastle Upon Tyne: Oriel Press, 1971)

Whittaker, Neville, *The Old Halls and Manor Houses of Durham* (Newcastle upon Tyne: Frank Graham, 1975)

Wilkes, Lyall, *John Dobson: Architect and Landscape Gardener* (Oriel Press, 1980)

Wills, Margaret, *Gibside and the Bowes Family* (Newcastle and Chichester: Society of Antiquaries of Newcastle Upon Tyne & Phillimore & Co., 1995)

Worsley, Giles, *England's Lost Houses from the Archives of Country Life* (London: Aurum Press, 2002

Newspapers, Journals and Periodicals

Archaeologia Aeliana (Journal of the Society of Antiquaries of Newcastle Upon Tyne)
British Archaeology
Daily Mail
Daily Mirror
Daily Telegraph
Darlington and Stockton Times
Durham, Tees Valley and North Yorkshire Life
Durham, Tees Valley and North Yorkshire Living
Evening Chronicle
Horse and Hound
Mail on Sunday
News Guardian
North East Life
Northern Echo
Sunday Telegraph Magazine
Sunderland Echo
Teesdale Mercury
Telegraph and Argus
The Times

Country Life (featured houses)

Streatlam Castle, 8 December 1915
Swinburne Castle, 27 February 2003

Illustration Credits

Matthew Beckett very kindly allowed me to reproduce the following photographs from his superb website www.lostheritage.org.uk:

Biddlestone Hall, Cresswell Hall, Elswick Hall, Farnacres (close up), Felton Park, Greatham Hall, Haggerston castle, Heaton Hall, Herrington Hall, Hetton Hall, Ravensworth Castle, Stella Hall, Streatlam castle, and Swinburne Castle.

The photograph of Newton Hall Durham is reproduced from their collection by kind permission of Durham University Library and I am grateful to the library staff for locating the images.

I am most grateful to Paul Ternent for his assistance in providing the illustrations of Bank House Acklington, Hollymount Hall and Ravensworth Castle (interior) which are reproduced with permission from the collection of Northumberland County Archives.

The photographs of Benwell Cottage, Benwell House, Benwell Old House, Benwell Park, Elswick Hall (aerial view), Elswick House, The Gables and West Acres are reproduced by kind permission of St James' Heritage & Environment Group and I am most grateful to them and especially to Ian Farrier for his enthusiasm and profound local knowledge.

The illustrations of Pandon House, Red House and Stotes Hall are reproduced by kind permission of Newcastle Libraries with my sincere thanks to Sarah Mulligan.

The illustrations of The Hermitage, Ravensworth Castle (interior) Saltwell Old Hall, South Dene Tower, Stella Hall (interior) and Sheriff Hill Hall are reproduced with thanks from the Gateshead Libraries Collection with sincere thanks to Jenifer Ball and Simon Green and also to Sandra Brack for making connections.

The photographs of Little Usworth Hall and Usworth House (Peareth Hall) appear thanks to the generosity of the Washington History Society to whom I offer my thanks.

The photo of North Elswick Hall is by C. J. Ford, to whom I am most grateful. The illustrations of Pallion are reproduced from the collection of the Photo Memories Organisation by kind permission of John Moreels MBE.

The Images of Ashbrooke Hall and Gateshead Park in industrial use are from the Historic England Collection and appear due to the persistence of Nigel Wilkins in finding them and making them available.

The photographs of Tunstall Manor and Tunstall Court are reproduced with the permission of Hartlepool Borough Council/Museum of Hartlepool (copyright reserved) and I am immensely grateful to Mark Simmons for his kind assistance in making it possible for me to use them.

I am grateful to the Crookhall Foundation website for the photographs of Crook Hall taken shortly before its demolition. The illustration of Hallgarth Hall is reproduced by kind permission of Winlaton Local History Society and I am grateful to Susan Lynn for her assistance.

The photographs of Cockerton Hall, Uplands and Woodburn are from the collection of Darlington Centre for Local Studies with thanks to Katherine Williamson.

The figures of Bainbridge Holme, Bishopwearmouth Rectory, Ford Hall, Low Barnes and Moorhill were provided by Trevor Thorne to whose exceptional generosity and distinction as a local historian I am most grateful.

Tyne and Wear Museums Service kindly allowed the reproduction of the image of Low Barnes, Sunderland. The photograph of Low Gosforth House is from Discovering Heritage.com with grateful thanks.

The picture of Twizell Castle was very kindly provided by Trevor Swan and the Coldstream & District Local History Society.

Other illustrations are either from my own collection, reproduced from old published sources (listed in the bibliography) or in the public domain. If I have omitted anyone who kindly gave me permission to use their images, I can offer my sincere (if unacknowledged) thanks and apologies. Every effort has been made to contact copyright holders but if I have inadvertently used any copyright images, please accept my sincere apologies. I would be delighted to offer acknowledgement in future editions.